# Painting the Figure

IN PASTELS

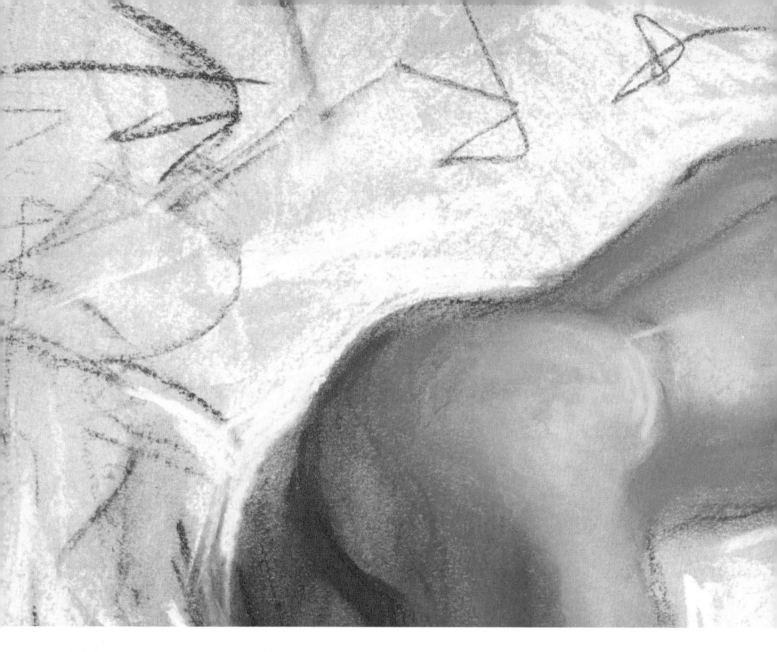

English translation © Copyright 1996
by Barron's Educational Series, Inc.
Original title of the book in Spanish is *Figura al Pastel*
© Copyright 1994 by Parramón Ediciones, S.A.,
Barcelona, Spain
Author: Parramón Ediciones Editorial Team
Illustrator: Vicenç B. Ballestar

*All inquiries should be addressed to:*
Barron's Educational Series, Inc.
250 Wireless Boulevard
Hauppauge, New York 11788

Library of Congress Catalog Card No. 95-32962

International Standard Book No. 0-8120-9398-4

**Library of Congress Cataloging-in-Publication Data**
Sanmiguel, David.
    [Figura al Pastel. English]
    Painting the figure in pastels / [author, David Sanmiguel ;
illustrator, Vicenç Ballestar].
        p.      cm. —(Easy painting and drawing)
    ISBN 0-8120-9398-4
    1. Human figure in art.   2. Pastel drawing—Technique.
    I. Ballestar, Vicenç.   II. Title.   III. Series.
NC880.S28    1996
743'.4—dc20                                           95-32962
                                                            CIP

Printed in Spain
6789   9960   987654321

# Painting the Figure

## IN PASTELS

**BARRON'S**

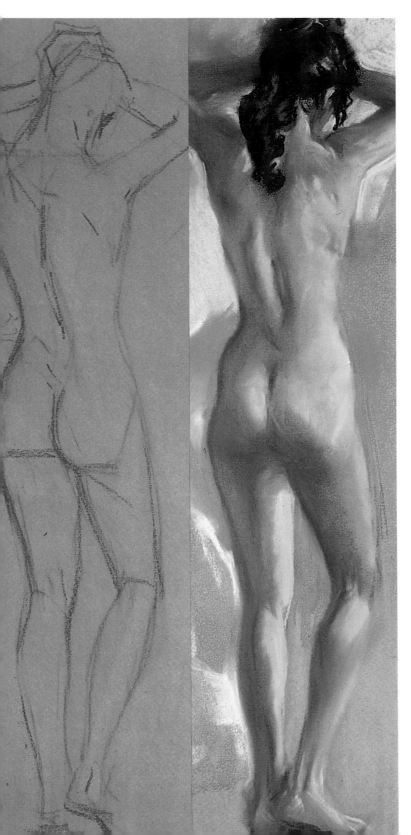

# CONTENTS

*T*his volume deals with pastels, a medium employed by the Great Masters studied in Art History and by many of today's artists. Pastels, a medium that falls somewhere between drawing and painting, are renowned for facilitating immediate expressiveness, looseness, freshness, speed, and daring, and for allowing the artist to suggest sensuality, attractiveness, and a dreamy idealism.

The pastel medium had a privileged position for many distinguished classical artists (Leonardo da Vinci, Quentin de la Tour, Ramon Casas) as well as for countless impressionists (Edgar Degas, Toulouse-Lautrec, Mary Cassat).

With just a few pastel sticks and paper, artists are able to express their feelings in countless forms. Apart from certain techniques, such as blending, the procedure depends on each individual artist. You may choose to paint a landscape, seascape, still life—pastel is suited to practically any theme. But given this medium's wide range of tones and vaporous effects, and its ethereal, delicate, spiritual, and almost mythical nature, most pastel artists have found pastels particularly effective for painting the figure, especially nudes.

This is the main reason for writing this book. Thanks to the work of an experienced artist, who has prepared a series of explanations and exercises with magnificent results, it will enable you, too, to express, manifest, and transmit your vision of the human figure through art.

Before going on to our experienced artist's teachings, however, allow me one final comment. The pastel medium should be handled in a fresh, loose, and daring manner, but this apparent spontaneity requires study, practice, and precision; careful observation and contemplation are needed before those first strokes are applied. Pastels do not tolerate much correcting or overworking; when you paint, make sure you have formed your ideas before going ahead at each new stage of the picture. This is the best way to produce good results that, without doubt, will give you great satisfaction.

Jordi Vigué

# PASTELS: THE MATERIALS

*T*he word "pastel" derives from the Latin word for paste, which refers to the paste with which the crayons are made: a mix of pigment powder, a little water, a small amount of gum arabic (or tragacanth), and an equal part of chalk, depending on how light or dark the color has to be.

There are two basic types of pastels: hard and soft. The soft ones are cylindrical in shape and enable the artist to cover large areas of the paper. They come in a wide range of colors. The hard type, made in thin sticks with beveled edges, are ideal for drawing thin lines and details. The directness and immediacy of color make pastels a marvelous medium. We will now look at the different brands of pastels and the most suitable paper to paint on.

## BOXED SETS

The most common hard pastels are manufactured by Faber-Castell or Conté (A). Faber-Castell has sets of up to 100 colors, and Conté, of up to 72. Numerous companies sell high-quality soft pastels. The prestigious French company Sennelier markets 525 colors. This same company sells sets of 25 to 250 colors (B). Other well-known soft pastel brands include Rembrandt (sets of up to 225 colors) (C), Schmincke (D), Rowney, Holbein, Grumbacher, Weber, and Talens Van Gogh.

A

## SPECIAL SETS

In addition to the boxes of hard and soft pastels, there are sets of pastel pencils (hard lead type) also available (E). Sets containing an assortment of pastel pencils, soft pastels, Conté crayons, and charcoals, sold by Koh-i-noor, are ideal for small format drawings (F).

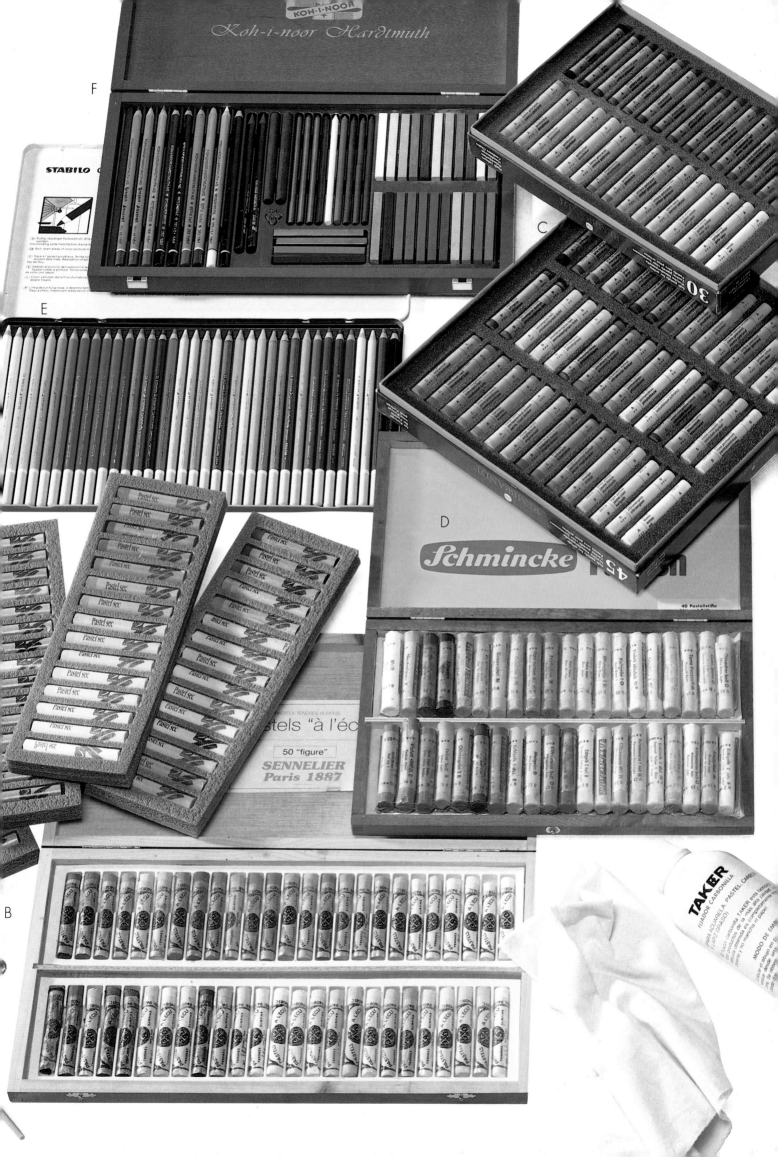

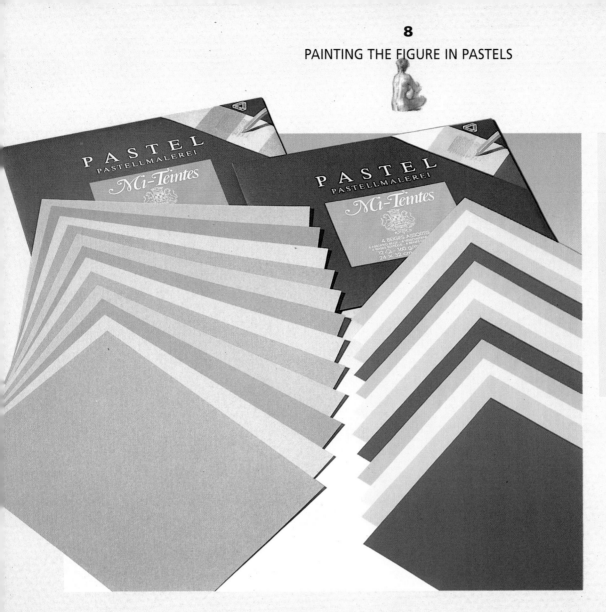

### CREATING YOUR OWN RANGE

Professional pastel artists work with a multitude of colors, although some of the colors they use are not available on the market. One artist, for instance, may use almost an entire range of ochres and siennas but hardly touch greens. To create your own range, you have to paint. After several paintings, note which colors you have used the most; these are the colors of your own particular range.

## COLOR RANGES

Since pastels cannot be mixed on a palette before being applied to paper, pastel artists need to work with a wide range of colors. It is therefore a question of painting with many different tones. This does not mean you cannot use your fingers, or even apply small touches of neighboring tones to produce an optical blend, so that the tones appear as one single color when seen from a distance.

To ensure a clean and sharp result, you should try not to use too many blends, because the color of the pastels may become muddy, gray, and opaque.

Another reason for painting with many unblended colors is the importance of the stroke or line. The stroke enlivens the surface and provides it with the characteristic texture of pastels.

Note the limited range of colors at the bottoms of these pages. These colors are adequate for beginning in this medium. Naturally, this range will have to be increased as you gain more experience in painting with pastels.

| YELLOW LIGHT | ORANGE | PERMANENT RED LIGHT | MADDER LAKE | PINK | VIOLET RED LIGHT | CARMINE | LIGHT PINK | VIOLET BLUE |
|---|---|---|---|---|---|---|---|---|

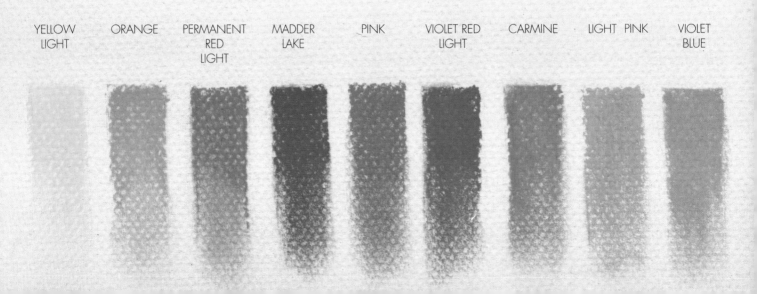

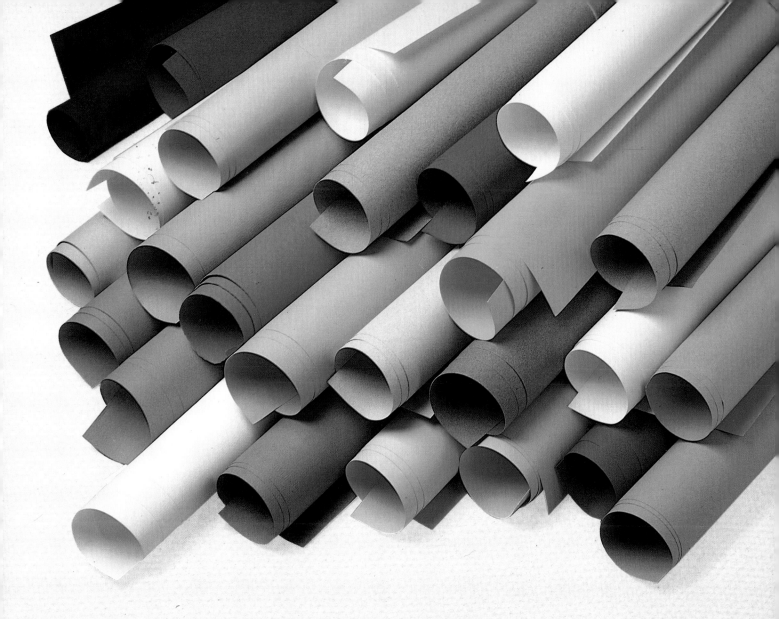

## PAPER FOR PASTELS

Pastels can be used with any type of paper or illustration board that is not too slick or glossy. Any kind of textured surface that has a grain that allows pastels to adhere is suitable for this medium.

Paper is used most often, as long as it is rough enough. Fine-textured paper permits the surface to be filled in quickly. Pastels run smoothly over such surfaces, but successive coats are difficult to apply because the grain of the paper is soon coated with pastel. Rough paper, on the other hand, has tiny holes that do not fill up with the pastel so fast. Therefore, it is better to work with rough paper, which not only allows you to apply successive coats but also lets you achieve very interesting results. Canson paper is especially suited for pastels. This brand has a wide range of colors, an important feature in pastel painting, since a white background makes the result appear harsh. The artist can choose a tone that is more in line with the harmony of the subject. Paper can be purchased in sheets of differing sizes or in rolls.

| ULTRAMARINE BLUE | BLUE | TURQUOISE | PERMANENT GREEN LIGHT | OLIVE GREEN | BURNT SIENNA | MARS VIOLET | BLUISH GRAY | BLACK |
|---|---|---|---|---|---|---|---|---|

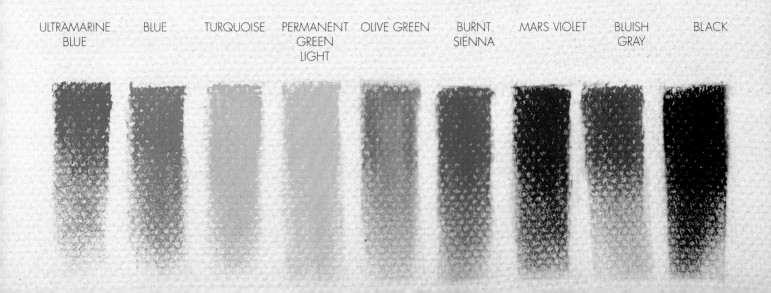

# PASTEL PAINTING TECHNIQUES

*S* *hading, blending with stomps, and combining different colors of pastels are almost the only techniques in this medium. Pastel painting involves working with pure color. There are no brushes or palettes, only the artist applying the pastels directly to the paper, using his or her fingers as the work tools.*

## STOMPS AND RAGS

It is best to blend with your fingers, although you can also use a paper stomp or a rag. Whatever you use, remember that blending removes lines and replaces them with a coat of homogeneous color free of abrupt tonal changes. A paper stomp is best when working on details and small areas; a rag works well for applying sweeping shadings of color to larger areas. A good substitute for the stomp is a piece of cotton.

## BLENDING WITH YOUR FINGERS

To blend with your fingers, gently rub the previously applied layer of pastels. Once this is done, new strokes can be painted over the blended area, and these can in turn be blended if necessary. Blending enables you to obtain soft gradations of a color, as well as combinations of two colors.

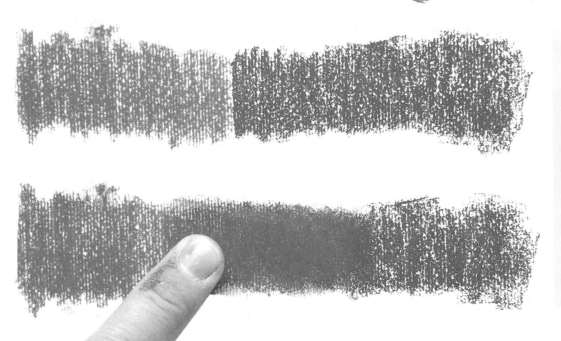

### DON'T BLEND TOO MUCH

Too much blending can cover the texture of the paper and make it extremely difficult to paint over an area with new colors. In addition, excess blending or rubbing tends to gray hues and to remove color. The best advice is to avoid going over any specific area too many times.

## ERASING

When painting with pastels, you cannot afford to make too many errors with color; it may be impossible to correct or change the work afterward. One way to keep this from happening is to start with the hard pastels and finish off with the softer, more adhesive ones. It is important to paint the darker parts of the picture first and then continue with the lighter ones. It is easier to correct a color by lightening it than by darkening it. Therefore, if you are not sure about a color, you should try the more intense hue first instead of the less intense one.

As already mentioned, it is difficult to recoup or save a painting that has been worked on too much. But at the beginning, or even at the end of the work, there are a few tricks that can be employed to remove pigment.

Now that we have warned you, we should say that pastels can be partially erased with a rag or some cotton. It is also possible to remove pigment with your fingers or, of course, with a kneaded eraser, which is very effective in erasing but also destroys the texture of the paper. If you want to paint another color on top of an erased zone while maintaining the background color, you must first fix it. Then you can paint over it without problems and even use a stomp to blend if necessary.

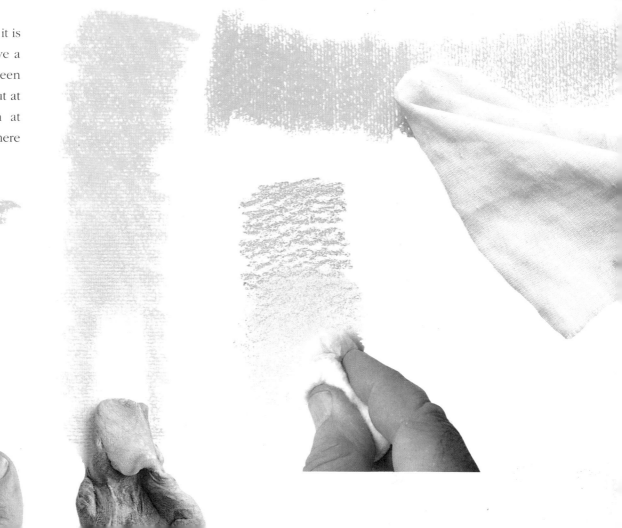

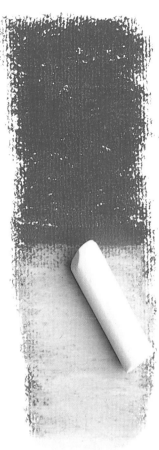

## LIGHTENING AND BLENDING COLORS

One way to lighten a value is to paint white over the original color. But, as is usual in this medium, too much white can produce very negative results. In the case of pastels, too much white grays the colors and gives the tones a rather plaster-like appearance. One of the reasons there is a such a great choice of colors is to help the artist avoid using white to lighten tones. A brief glance at all the pastel colors available reveals the enormous range of shades between two neighboring colors, some of which are so subtle that it is hard to tell one from another. The ideal solution to the problem of lightening a value is to have one stick for every tone needed and to use white only as a pure color. This, of course, is not always possible, and it is normal to have to lighten a color with white occasionally.

While we are on the subject of combining colors, we should point out that it is always best to mix colors in order to lighten the values rather than to darken them. It is easier to lighten a brown with orange than to darken an orange with brown.

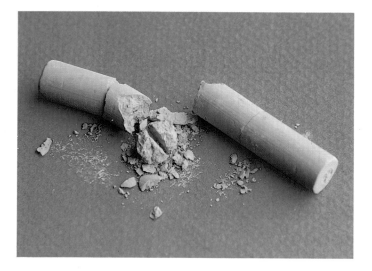

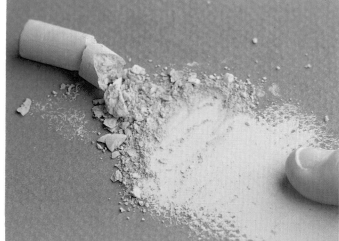

## TAKING ADVANTAGE OF THE MATERIAL

One of the drawbacks of pastel painting for beginners is the fragility of the sticks. This problem is even worse when working with soft pastel sticks. Pastel sticks break easily, and certain tones tend to crumble. To keep these from becoming problems, break the sticks into small pieces instead of using the entire sticks to paint with. This will give you greater control over the stroke and will allow you to take better advantage of the color. It is essential to keep the loose pieces in a box; even the smallest fragments can be put to good use.

## FIXATIVE

A pastel painting must not be fixed. Fixative changes the intensity of the colors, hardening some of them and absorbing others, thus altering the chromatic relation between the colors and ruining the strokes and lines.

The illustrations at the bottom of this page show a painting before (left) and after (right) being treated with fixative. Pay special attention to the result: the greens have become darker; and all the blues have been reduced to a similar tone, losing the diversity they had before the fixative was applied. You can use fixative whenever necessary throughout the painting process if you will be painting over it, but you should never use it at the end of your work.

# PAINTING THE HUMAN BODY IN PASTELS

*P*astels are a good medium for studies of the human body, especially those drawings in which the modeling of the limbs is highlighted. Therefore, pastels are ideal for painting nudes. The special characteristics of pastels make it easy to draw the shape of the human body. Applying and blending strokes of just one or two colors is sufficient to obtain volume.

The examples on these pages demonstrate the simplicity of the pastel medium; the only complication is the obligatory correction of the drawing, something that is essential in all mediums.

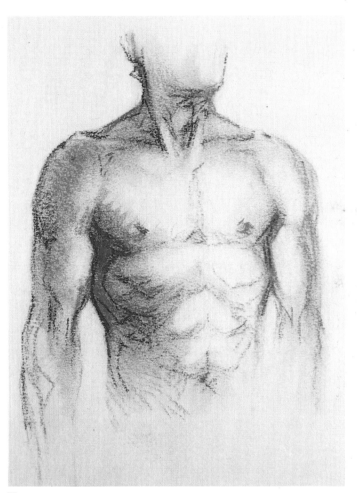

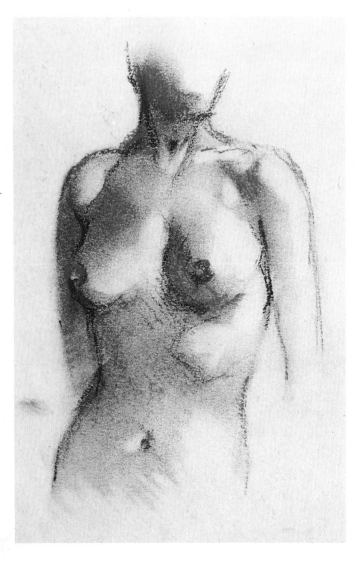

## THE TORSO

The torso is one of the most common themes of anatomic art. It is the most interesting part of the body because of its unique characteristics. The male torso possesses a wide range of muscles that stand out in a complex and rich relief; the female torso is more homogeneous and smoothly rounded. It is essential to master human anatomy to be able to develop this subject matter correctly. The male and female torsos shown here were painted in pastels using two colors: English red (very similar to sanguine) and burnt umber, common colors for drawing figures. Using these two colors makes it easier to emphasize the forms and develop the pattern of light and shade. The illustrations show the different treatment of the male torso (in which unblended lines predominate, thus highlighting an energetic modeling) and the female torso (with the pastel drawing blended, creating a soft and continuous modeling). Keep these two approaches in mind when embarking on a picture.

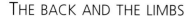

## THE BACK AND THE LIMBS

It may appear easier to paint a figure from behind, but this exercise presents its own problems. When painting a figure from behind, you must take great care to correctly situate the line that marks the spine; it is the line that determines the movement of the figure. You can use your fingers to increase the blending and the fusion of color because the shape of the back is more continuous and smooth than is the shape of the torso. In these examples of legs and arms, you see how white has been added to the color range. When working on colored paper, white is useful for situating and emphasizing highlighted areas of the limbs. Note the importance of blending along the edges of the drawing; the light shadows that appear within the lines of the sketch are the result of rubbing with the fingers over the line of the contour, emphasizing a slight darkening, which expresses the roundness of the shape.

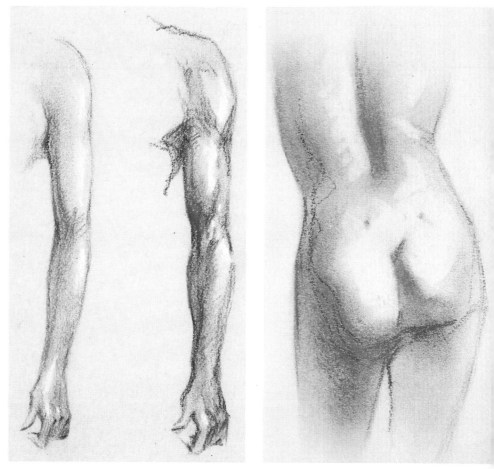

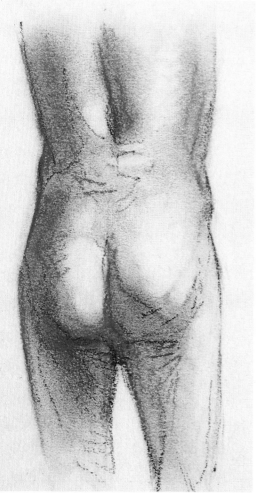

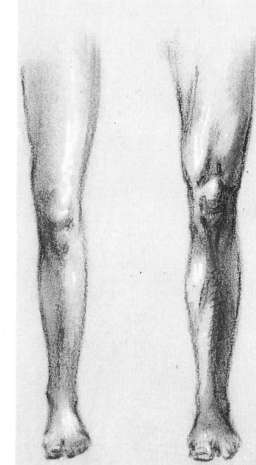

### ALWAYS REFINE A PAINTING

It is necessary to refine colors by blending with your fingers, even when you are working with all colors. Light and shadow, or chiaroscuro, is created by contrast not only between two intensities of the same color but also between different hues (such as red and orange, or green and pink). This enhancement is responsible for the sense of volume and form that a pastel figure must possess.

# A FEMALE BUST IN THREE COLORS

*T*he first exercise of this book involves drawing a female bust by shading—that is, working with chiaroscuro in gray, black, and white, although the "grays" are represented by reds and browns, and the "blacks" are a mixture of the three colors. In this exercise, we will concentrate on the three-dimensional aspects of the form and on anatomical accuracy. This is a perfect introduction to pastels, a medium that involves drawing and painting at the same time.

## MATERIALS

- White Canson Mi-Teintes paper
- Pastel or Conté pencils in sanguine (or English red), sepia (or burnt umber), and black
- Rubber eraser and kneaded eraser
- Clean rag
- Drawing board, plus pins for attaching the paper

The dark shadow in the background is the result of superimposing the three colors. Note how the strokes follow the same direction, not only here but also in the whole background. The lines were applied by holding the crayon at the end.

The shadows of both the face and shoulder were developed by blending with the fingers. This process erased the lines. In order to achieve this effect, it is necessary to draw extremely softly.

**1** Before beginning to shade, it is essential to draw a basic sketch: four lines to define the figure and situate it within the format of the paper.

**2** This is the first stage of the shading process. Note how the pencil is held: by the end or even in the middle. This enables us to fully control the length of the stroke that, as you can see, is creating a homogeneous shaded area.

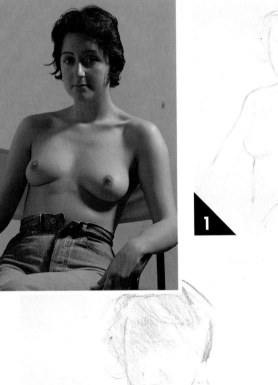

**3** Having shaded the first area, we spread the color over the entire surface of the paper by blending with our hand. This blurs the contours of the figure somewhat but has the advantage of creating a series of vague shaded areas that represent the basic chiaroscuro. The role of these shaded masses is to act as a guide throughout the rest of the drawing.

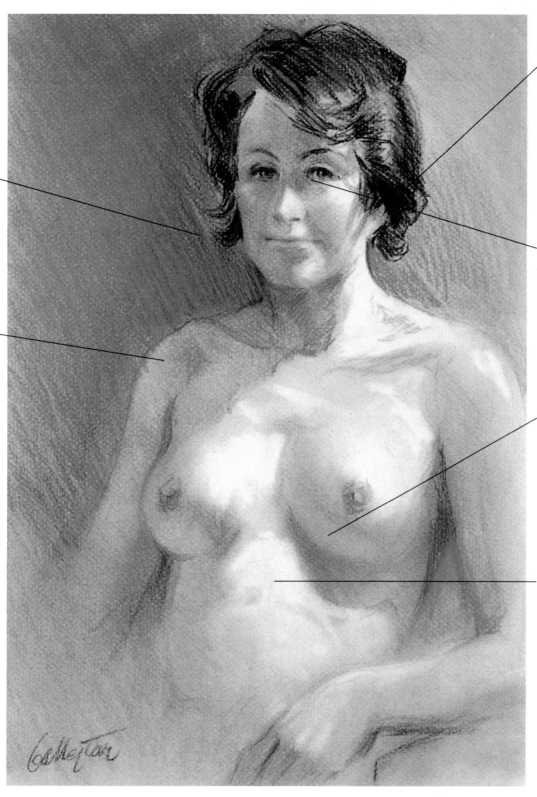

The darkest parts of the hair were drawn with black superimposed on the shadings and gradations of the other two colors. These other colors can be seen in the highlights of the hair. Note how the lines follow the direction of the hair.

The shaded area of the face has a certain amount of detail, among which are dark accents (drawn in black) to emphasize the features. The blending here was carried out with the fingers.

Meticulous shading emphasizes the roundness and volume of the breast. The work consists of successive layers of shadings and blendings. The light areas of the breast sharply contrast with the darkness of the shadow below.

This pure white was created by "drawing" with the eraser, reducing the shadow of the breast and creating a very sharp contrast between light and shadow.

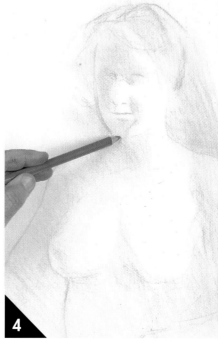

**4** Once we have blended the first strokes, we use the sanguine Conté pencil again and restore some of the more important contours, such as those of the chin and breast, and several lines that define the hair. We also darken the curve of the upper eyelid, which establishes the position of the eyes. These dark areas are intensified before we begin the task of refining the work.

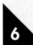

**5** We use the eraser over the sanguine shaded area (which has been almost entirely blended with a stomp) to lift out the color and situate the highlights of the drawing.

**6** The essential guide to the lightest parts of the drawing is now complete. It is now time to add detail and to darken the shadows of the head. The large shadow of the background offsets the highlighted part of the hair; this contrast creates the shape of the head. From here on, it is a question of developing this type of contrast.

**7** Having exchanged the sanguine for sepia and a black Conté pencil, we outline the dark areas of the hair. The darkest shadows correspond to the right temple and the hair that falls over the forehead.

**8** Using the sepia Conté pencil, we create a new intensity of applied shadows on the left side of the head. The contrast of tones (sanguine on the right and sepia on the left) is interesting.

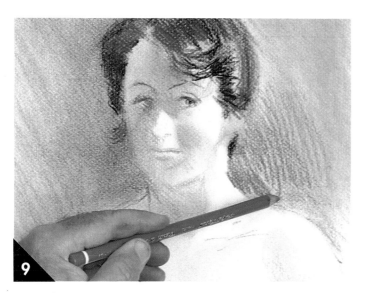

**9** By superimposing the sepia color over the sanguine without blending, we have darkened the hair and defined its color. Here the direction of the strokes and the light areas left on the paper to represent highlights are important elements when depicting the hair.

**10** Blending with the fingers; soft parallel strokes with the pencil; intensification of the lines of the hair, eyes, mouth, etc.; and use of the eraser to create highlights—all these contribute to the resolution of the head. Here we continue at the base of the neck and draw the shadow of the hollow of the collar bone.

**11** The highlights lifted out with the eraser are always irregular and must be refined. It is necessary to soften and blend the pastel strokes in order to create a subtle transition from light to dark.

## WORKING WITH PASTEL PENCILS

Since we are using pastel (or Conté) pencils here, it is a good moment to remind you that such materials are not as suitable for filling in large areas as are pastel sticks. For this reason, the strokes should always be applied in the same direction to obtain a homogeneous shading of color, which can then be blended if necessary.

**12** This is the current state of the picture. The refining and modeling of the head are at a very advanced stage in comparison to the rest of the body, which is still only a sketch. It is interesting to observe the shadow cast on the shoulder, which gives a sense of space and depth to the picture as a whole.

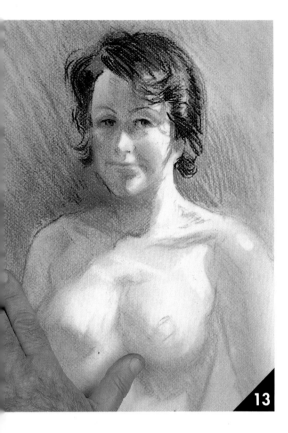

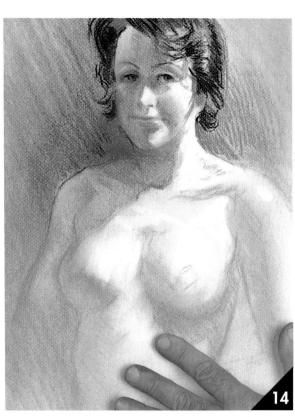

**13** The difficult process of drawing the breasts from a frontal point of view requires a distribution of lights and shadows. Here we have darkened the lower right side of the breast.

**14** The darkest area on the far left side of the shadow is intensified with some more shading.

**15** To finish off the breast, we bring out the shape and color of the nipple with some soft sanguine strokes. Note how the shape of the breast is formed of two different shadows: a darker one, in the lower part, and a softer one, above, creating the sensation of volume and roundness.

**16** The edge of the shadow is erased to reinforce the chiaroscuro. The eraser removes all color from the area, giving us a pure white, which contrasts with the darkest color of the shadow.

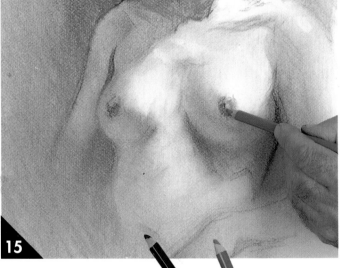

**17** Now and again, it is necessary to remove the pigment that blending has deposited on our fingers. This should especially be done during the final stages of the picture, when a smudge or stain would be most noticeable on the drawing.

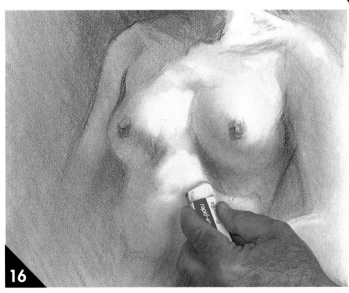

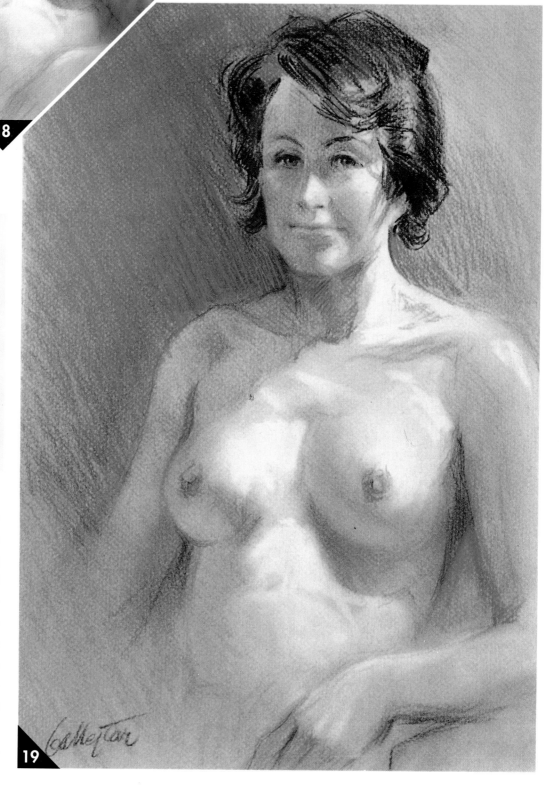

**18** These are the final touches to the picture. As we mentioned earlier, just beneath the breast is a soft shadow, and in the lower part is another, darker one. We finish by blending this area to lighten it to create a reflection.

### WORKING VERTICALLY

Even though they are in pencil form, these pastels cover the paper almost as well as pastel sticks do. Working with pastels on paper held in a horizontal or slightly slanted position greatly increases the chances of dirtying the hands and soiling the drawing. For that reason, always work with your paper and drawing board held in a vertical position.

**19** Here is the finished picture. As you can see, the job of correcting and refining is meticulous. We have paid attention to the most important details and have developed and added only those finishing touches essential to the completion of the composition. Examples are the details of the hair and face, with their transitions from light to dark.

# A MALE FIGURE WITH HIS BACK TURNED IN FULL COLOR

*W*e are going to throw you in at the deep end with this exercise. As you can see in the photograph of the model, the subject is a male viewed from behind and illuminated to show strong contrasts of light and dark, or chiaroscuro, in order to emphasize the most relevant anatomical features. This time the color will have to be taken into account when evaluating and modeling. Since we are not constrained by a limited choice of colors, let's see how this problem is resolved.

## MATERIALS

- Grayish brown Canson Mi-Teintes paper
- Complete range of pastels, mainly warm colors
- Rubber eraser and kneaded eraser
- Clean rag
- Drawing board and pins

Some parts of the paper are filled with white where the contrast between the flesh and the background is most intense. In addition, the white accentuates the dark shaded areas of the figure.

The highlight in the middle of the shadowed arm is important because it defines the elbow.

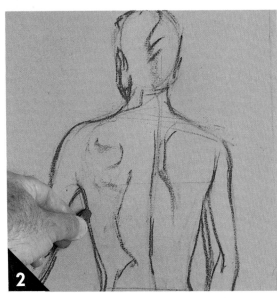

**1** The first stage of a drawing is to determine the arrangement of the figure on paper. Notice how the most important lines of the sketch are based on three factors: alignment of the spine, directional lines of the hips, and directional lines of the shoulders.

The pure and bright carmines and pinks of the drape covering the stool add to the chromatic harmony of the picture. This fragment is sketched with a few strokes of color, which are lightly blended.

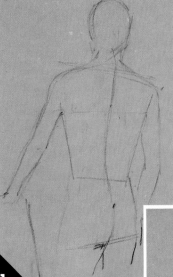

The color used for the darkest shadows of the figure is burnt umber. Sometimes some touches of blue and carmine are added to it; these become integrated into the burnt umber and are hardly visible in the shadows.

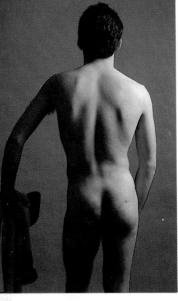

**2** Once we have correctly sketched the figure, we can begin to draw the form and the edges of the shaded areas. We are working with a stub of umber the same way we would use charcoal.

**3** To prevent the dark lines from spoiling or muddying the colors that will be applied later, we go over them with a kneaded eraser.

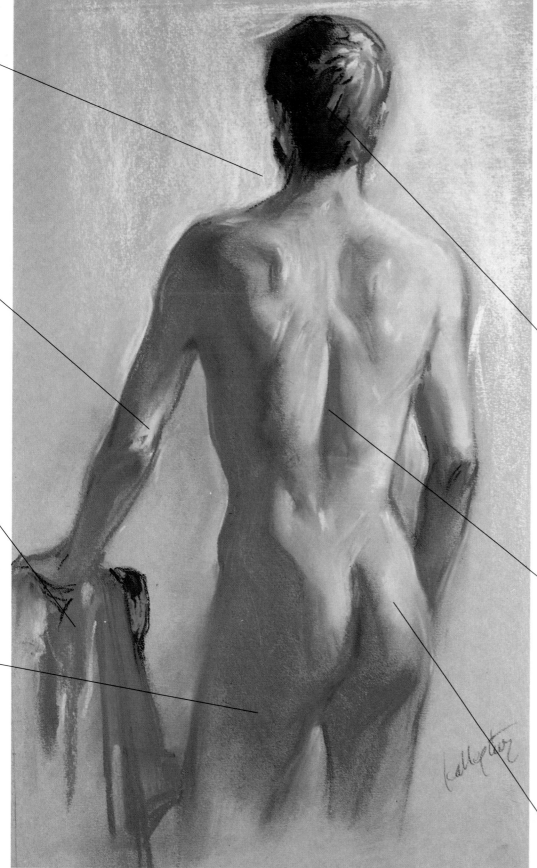

The hair was painted with the darkest color (burnt umber), to which some bluish highlights have been added. The direction of the stroke should always follow the line and direction of the hair.

The spine (an essential element in the representation of movement) is accentuated by an intense chiaroscuro. This contrast creates the fundamental shape of the back as well as the modeling.

We have added white to the figure's buttocks to highlight the lightest tones. White areas are also present in different parts of the back, but there they are used to define planes that do not belong to the smooth back itself.

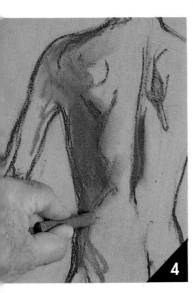

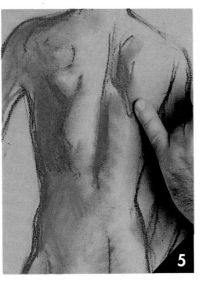

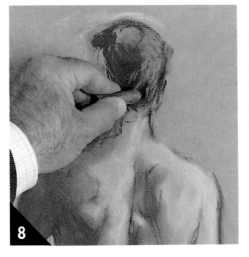

**4** We begin to paint the areas reserved for the shadows with loose strokes of madder, which we will then blend.

**5** Now the madder is blended. Note how the artist's fingers blend the madder with the burnt umber of the earlier drawing. This mixture produces a reddish brown tone, appropriate for the deep warm shadow needed for this work.

**6** This is the current state of the drawing. The distribution of shadows begins to reveal the general volume of the figure. We can also see how the highlights make their appearance, in the form of orange-yellow in the shoulders.

**7** We are blending the strokes of yellow that create the effect of light on the body. A few touches of white have been added to emphasize the highlighted areas of the anatomy.

**8** Here we are painting the hair, using blue to bring out the reflections. The color of the hair is brown, and the darkest color is painted in the same burnt umber used earlier. These touches of blue give variety and life to the dark area.

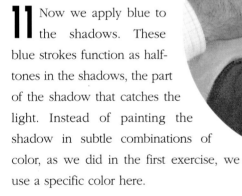

**9** The modeling is still incomplete. We have added some vibrant color notes, such as the drape on the stool. The parts of the shoulder in shadow on the left stand out against the pale pink of the background.

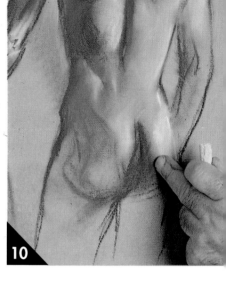

**10** The lightest parts are highlighted with white, which is then blended and spread over the entire area that was indicated by the lines of the original sketch. Take care not to use the same finger for all colors.

**11** Now we apply blue to the shadows. These blue strokes function as half-tones in the shadows, the part of the shadow that catches the light. Instead of painting the shadow in subtle combinations of color, as we did in the first exercise, we use a specific color here.

## THE COLOR OF FLESH

The problem of flesh colors is common in figure painting. Warm tones like ochres, yellows, and pinks are not sufficient to represent the pearly quality of skin. It is necessary, therefore, to add some cool tones. Blue is very appropriate for this purpose, as long as it is used with caution.

**12** Here we can fully appreciate the effect produced by the blue within the general color harmony of the picture: it deepens the perception of form and volume, and adds richness to the illumination of the figure.

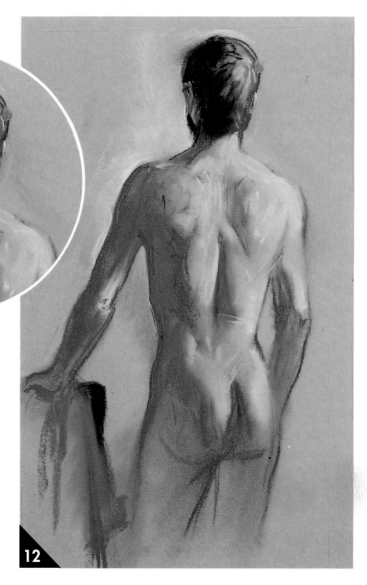

**13** Holding the pastel stick in a horizontal position, we fill in a large area of the background with white to bring out the general color harmony of the figure.

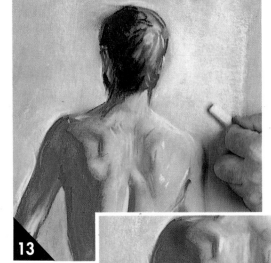

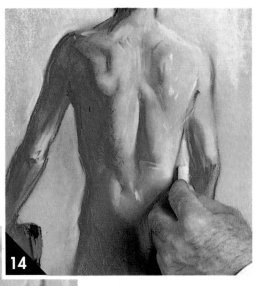

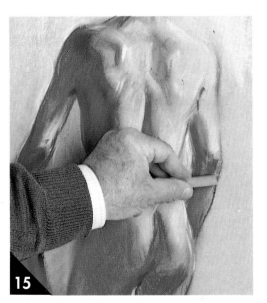

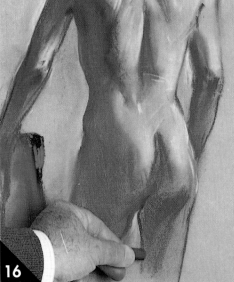

**14** We continue painting the background, this time working on the area between the arm and the trunk. By lightening the background, we soften the contrast between the warm flesh colors and the gray-brown tone of the paper, thereby creating an uneven and slightly discordant effect, which adds interest to the composition.

**15** The figure's contours are blurred by adding white, which we blend with our fingers. These lines are then immediately restated with burnt umber in the areas of dark shadow.

**16** We continue the task of redrawing lines by emphasizing the ones in shadow. This adds the last touches to the work that we have painted with a limited but sufficiently rich color range.

**17** We pause to let you see our method of working: standing up, in front of the easel to which the drawing board is attached. We keep the pastels on a table to our side and hold in one hand two or three of the sticks with which we are working.

**18** This is the finished painting. It was completed using a modest selection of colors. Note the role of blues in enhancing the chromatic range and refining the shadows.

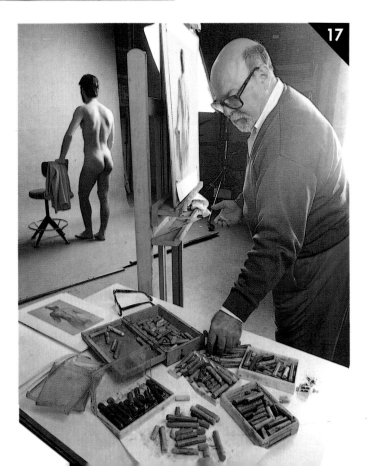

### THE COLOR OF THE PAPER

One of the advantages of working on colored paper is the possibility of varying the color of the paper itself, either contrasting it with or integrating it into the general color harmony of the picture. The paper may belong to the same color range in which we are painting, or it can be totally different in order to create contrasts.

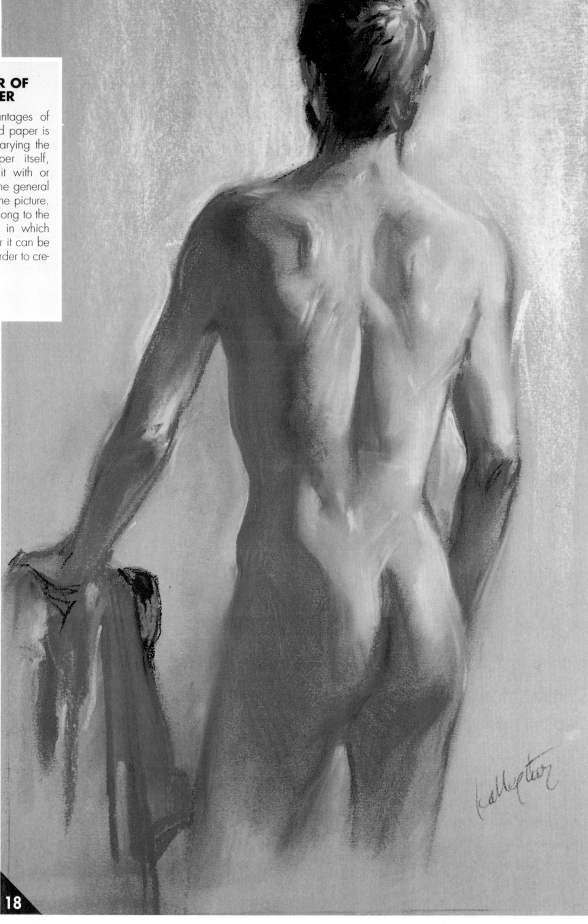

# A FEMALE FIGURE FROM BEHIND

*T*his time, we are going to paint a female from behind with a richer range of colors than we used in the previous picture. The reason for this is the different lighting on the model. Before, we worked with bright lateral lighting, which creates strong contrasts of light and dark. The frontal lighting we will work with now compels us to approach the model with a more colorist attitude, in which the contrasts of color are more important than the contrasts of value.

## MATERIALS

- Ochre Canson Mi-Teintes paper
- Complete range of pastels including greens, blues, and a wide range of warm colors
- Rubber eraser and kneaded eraser
- Clean rag
- Drawing board and pins

Although this arm is in shadow, it reflects the light. The work consisted of first applying a green layer, which was then darkened with carmine. Finally, the highlight was suggested by painting some pink on top.

The background is very free and abstract. Since the figure is small in relation to the background, a realistic background would only compete with the shapes of the figure. The blue drape behind the model is reduced to a few shaded areas.

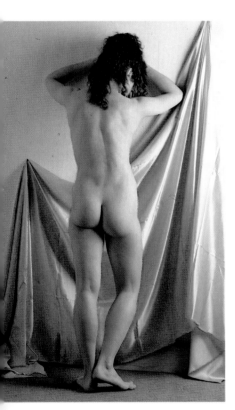

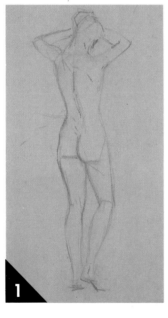

**1** Since the paper is the same size as the paper we used for the previous drawing, we will have to reduce the dimensions to center the figure within the format.

**2** Although you may not believe it, light green is a superb color for mixing rich flesh colors. We paint it in the half-tones of the back.

**3** This pale yellow represents the lightest parts of the body. Next to it, we apply a light pink, which softens the tone. We have started on the light areas because the shadows here are not so clearly defined.

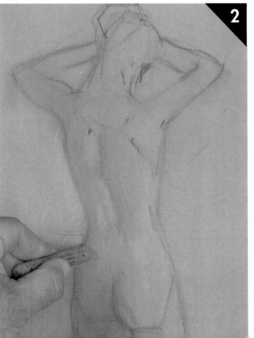

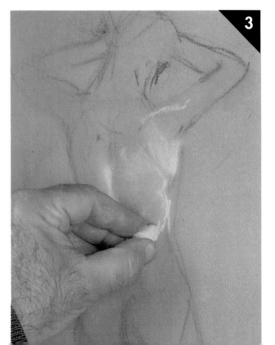

Many colors combine to make up the color of the figure's flesh—pink, ochre, and yellow, among others. But we should not forget the vital role played by the color of the paper, which provides a warm base over which the different flesh colors can act.

The light green was essential for indicating the reflected light on the back. This color, combined with the ochre and yellow of the illuminated parts of the flesh, is used to create the curve of the back.

The rounded shape of the thigh was obtained by successive blended layers of carmine, pink, and ochre. The transitions from one color to another must be subtle to avoid any abrupt breaks or changes in the smooth continuity of the form.

The plane of the floor is represented by the dark tones under the soles of the feet, which make the figure appear to be firmly positioned on the ground.

**4** We go over the line of the leg on the lighted side with yellow. This is a first suggestion of the highlights, the most illuminated areas of the figure, which we draw, without pressing down too hard on the pastel stick.

**5** Some pale blue is painted in the background, alongside the small of the back, where we let the color of the paper blend with the flesh colors.

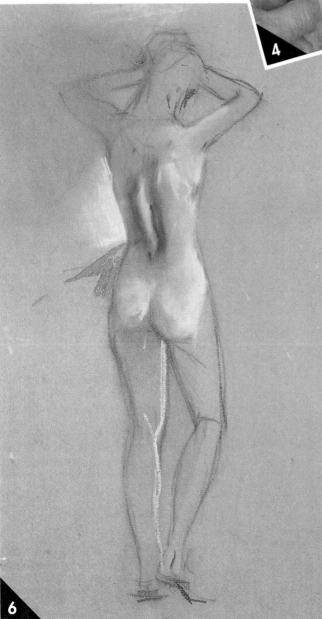

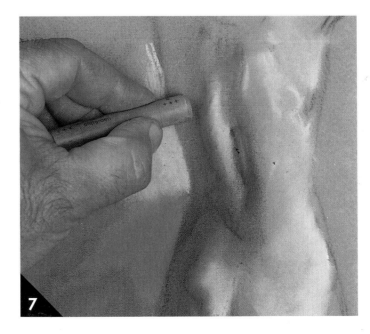

**6** At the end of this first stage of the picture, we can see the rich colors in the figure—blues, pinks, carmines, yellows, greens—colors that harmonize with one another, as well as with the color of the paper.

**7** We apply green again, this time on the left-hand side of the drawing, to create the sensation of reflected light. This green does not stand out too much from the color of the paper, allowing the figure to blend perfectly into the background.

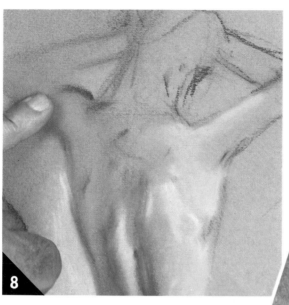

**8** We use our fingers to blend the green of the reflections with the carmine lines. There is no need to worry about "going over the lines," since this area can be softened or even covered with another color whenever we want.

**9** Using this very dark umber tone, we redraw the lines of the legs where they appear in shadow. These lines will be blended later and combined with other colors, but for the time being, the color of the paper itself helps to form the shape of the leg.

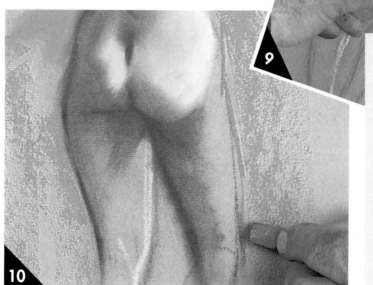

### DRAWING

It is possible to correct a pastel painting while working on it, as long as the correction is carried out during the first stages of the work. These revisions can affect the drawing. In any case, we advise you to touch up lines and contours as you go along and to develop the form through the use of color.

**10** To create a sharp contrast with the warm colors of the paper and flesh, we apply a light cobalt blue to the background, using the flat side of the stick.

**11** The contrast created by the addition of blue is now intensified with some pink along the outer part of the thigh. This contrast emphasizes the light falling on the nude model, and the light reflected from the blue drape creates a rich effect.

**12** We paint the hair with a dark umber down the back of the neck and between the shoulders. The color has to be dense to represent the hair, with the direction of the stroke coinciding with the direction of the hair.

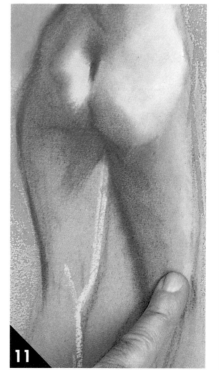

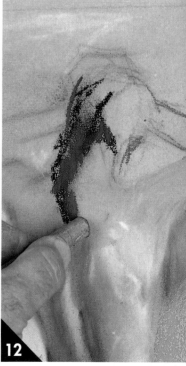

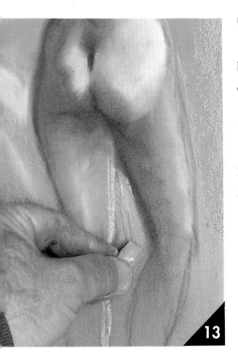

**13** We continue working on the blue background, carefully painting the area between the legs without touching the body itself. Note how the leg on the left displays a wealth of color that perfectly defines the rounded shape of the body.

**14** We add a few touches of ultramarine blue to the upper part of the hair to give the dark, voluminous mass some highlights, making sure that the blue does not appear as simple flat strokes.

**15** The painting is at an advanced stage now. The diverse assortment of light and shadow, and the cool and warm tones used for the flesh colors all contrast with the intense blue background.

**16** On the calf, we have attempted to create a deep shadow with the ultramarine (which appears almost violet because of the effect of the neighboring carmine) in order to show the nicely rounded shape of the leg.

**17** After we blended the blue, the outline of the leg was blurred, so we redefine the line of the leg by cleaning the smudges with an eraser.

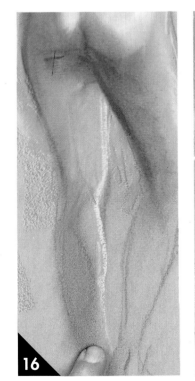

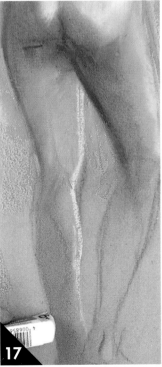

**18** The work on the calves and ankles is rather complex and delicate because of the problem of blending and shading in such a confined space. We have lightened the blue strokes with pink, and now, with a dark value, we are outlining the areas where the darkest shadows are cast.

**19** To intensify the highlighted side of the figure, we apply light ochre. This hue combines perfectly with both the flesh colors and the color of the paper itself.

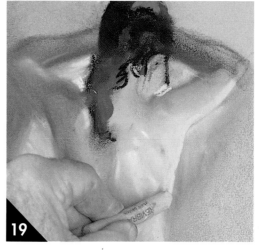

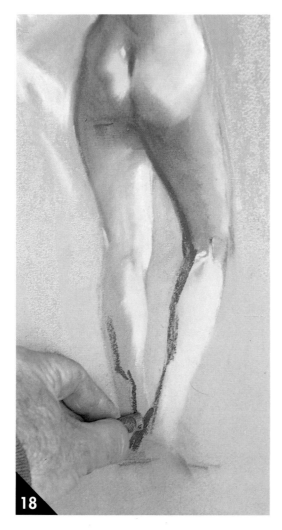

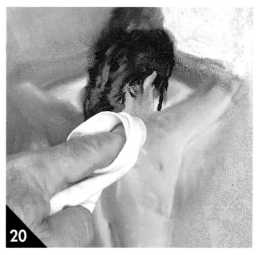

**20** We use the rag to blend and unify the multitude of values and colors that have accumulated on the back of the figure. This must be carried out with the utmost care to avoid erasing the color instead of merely blending it.

### ERASING AND BLENDING

A clean rag can be used for both blending and erasing color, although only a thin layer of pastels can be erased. Blending should be carried out with great care and gentleness, making sure that you do not press down on the paper more than is absolutely necessary. Naturally, you should also use the rag to clean your fingers.

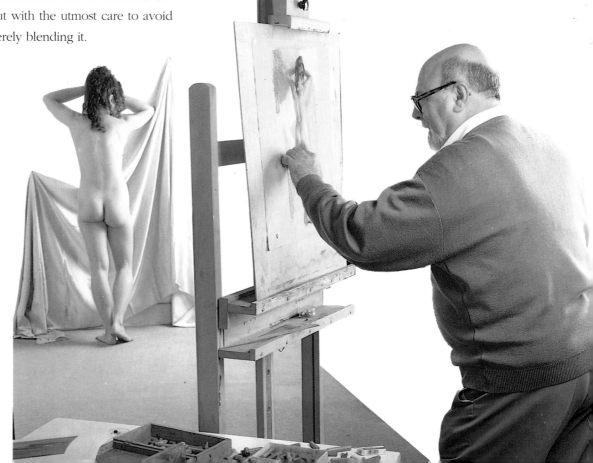

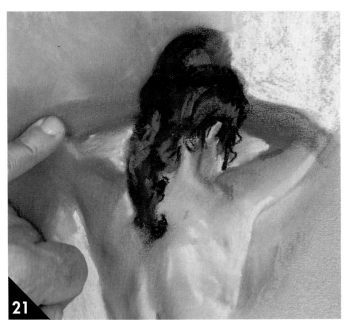

**21** We now complete the figure's arms, both of which are in shadow. We darken them with carmine, which we immediately blend with one finger. The resulting color is a mixture of the green that we applied earlier and the carmine we just laid over it.

**22** It is best to darken the areas where the figure is supported (such as the soles of the feet or the back). Here, we darken the soles of the feet, clearly indicating the plane of the floor.

**23** The strokes of white pastel on the blue background are inspired by the highlighted folds of the drape, but they also play a more ornamental and abstract role. It is not necessary to overload the picture with realistic details of the figure itself, especially when the figure is as small as this one in relation to the size of the background. The "abstract" solution is, on occasion, the best.

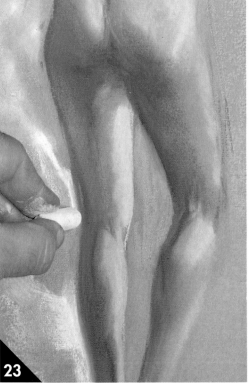

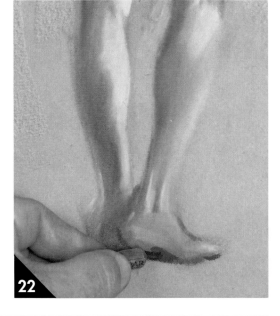

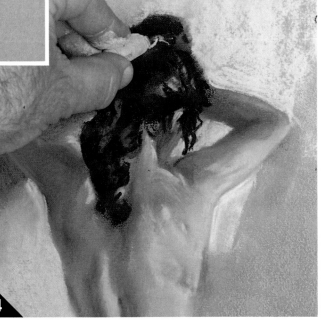

**24** The final touch consists of lifting out some highlights with the kneaded eraser to suggest the gleam of light on the hair. To do this, we first mold the kneaded eraser into a point, making sure that it is clean.

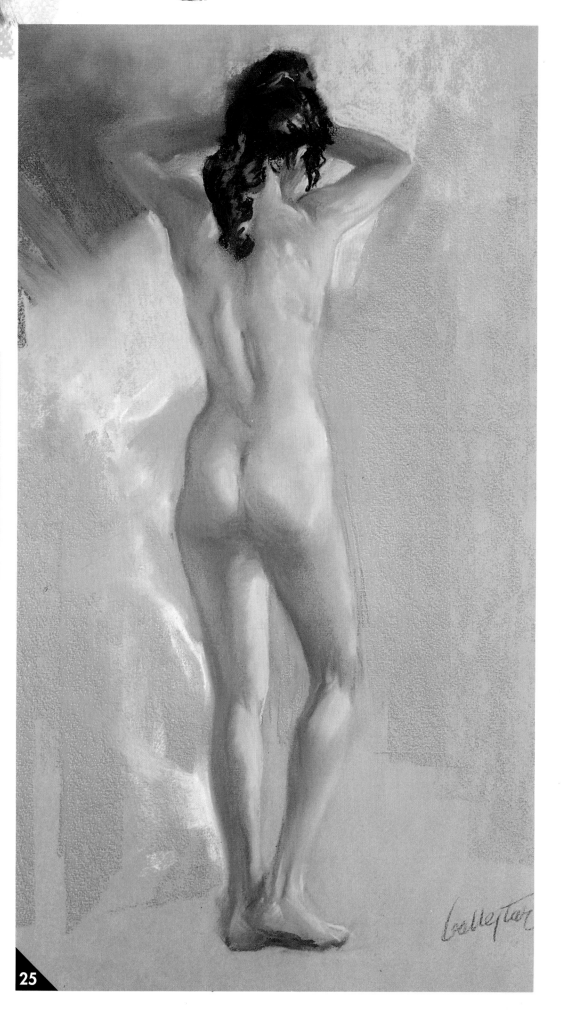

## THE KNEADED ERASER

A kneaded eraser can be molded into any shape you need for use on paper—from a very wide surface to a fine point. Any dirt on the eraser can be "removed" by kneading it into the mass of the eraser.

**25** This is the final result of our pastel painting, a result that we believe perfectly combines light and shadow with a wide range of very attractive colors.

# A RECLINING FEMALE NUDE

*W*e are now going to paint a figure in one of the classic poses of the genre. The harmony of lines it entails makes it one of the most popular themes for artists. The lighting will be bright, without any extremes of light and dark, thereby allowing the forms to be depicted in all their fullness and softness. The color harmony selected is also subtle, composed of sienna, yellow, pink, and light blue.

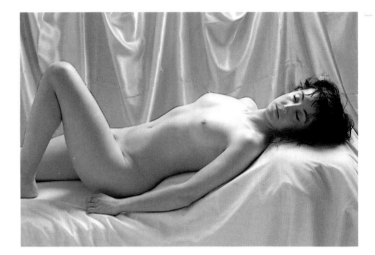

**1** The study of the pose is fundamental. Whenever we work in front of a model, we should sketch a few studies to try out a variety of possible compositions. These sketches can be shown to the model to let him or her know what kind of pose we are looking for.

## MATERIALS

- Light gray Canson Mi-Teintes paper
- Complete range of pastels including siennas, yellows, and pinks, as well as light blue
- Rubber eraser and kneaded eraser
- Clean rag
- Drawing board and pins

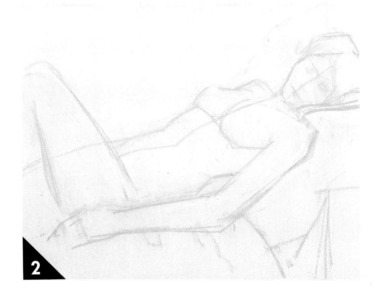

**2** The sketch of the pose itself is based on an angle, here formed by the trunk and the thigh. Using this as a guide, we block in the shape of the figure with straight lines. Note the line that divides the trunk—this is essential for modeling and giving the figure volume.

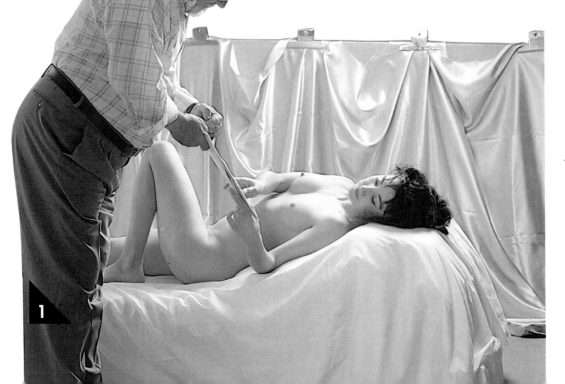

The background is a blended mixture of blue and white. It is not perfect, nor should it be. This kind of interrupted finish creates a feeling of enveloping light.

The highlights of the body are white. To avoid giving them a harsh appearance, we harmonized them with the flesh tones of the body by blending successive layers.

One half of the face is in light and the other part is in shadow. Note how the lighted side is more modeled, painted with only one tone, over which the eyelashes are carefully detailed.

The drape was painted in cool tones, composed of blues, whites, and grays. The colors are repeated in the background, so the figure is enveloped in a contrast of warm and cool colors.

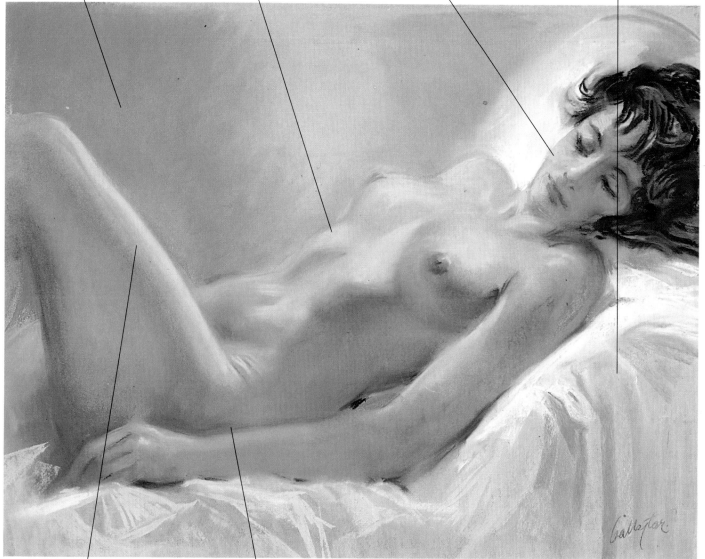

The leg is painted in long strokes of yellow, sienna, green, and pink. Each one of these colors corresponds to a different intensity of light, and they are combined in bands or successive layers in order to create a sense of three-dimensional form.

Since the shadows of the hip and the arm are the same value, we used the same tone. They are distinguished by the contour lines of the arm.

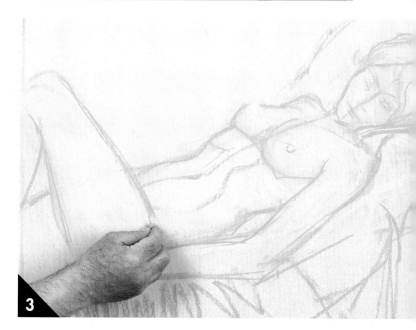

**3** We use a stick of pink pastel to sketch the initial composition of the figure. We try out various possibilities before reaching our final decision. Then we erase the unwanted lines with the kneaded eraser.

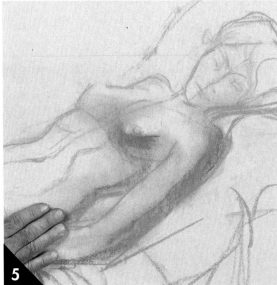

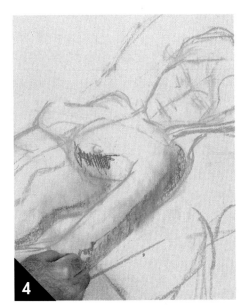

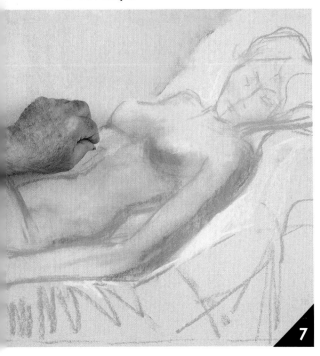

**4** We begin by painting the flesh with light warm colors, applying lemon yellow and burnt sienna with the flat side of the stick.

**5** Now we blend these first strokes by rubbing our hand over them in the same direction in which they were applied to obtain a clean, uniform, shaded mass.

**6** This is what the picture looks like after the first blending. The sienna of the body's shadow is similar to the shadow cast on a cylinder. The work is made easy by imagining the different parts of the body as geometrical shapes.

**7** Now we use white to add a few highlights to the lighted parts of the figure (such as the breast and the shoulders). In the same way, we darken certain zones of the hair and begin to fill in the background of the composition.

**8** Note the strokes that have been applied with the flat side of the pastel stick, using a loose hand and no blending. Light touches of color are introduced into the background in order to observe the effect on the whole composition. Strokes of pastel are also added in the creases of the drape.

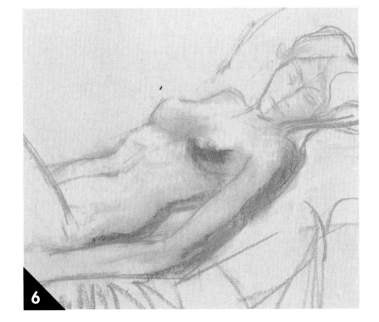

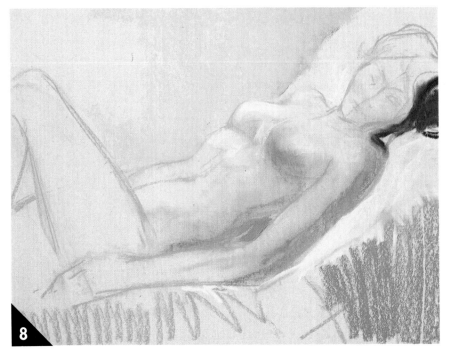

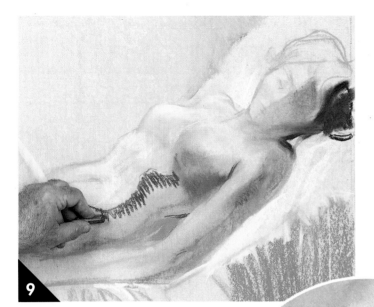

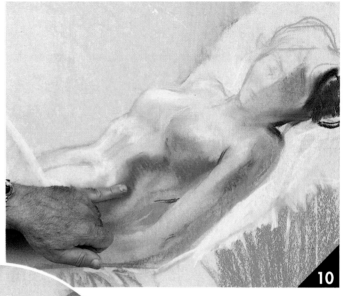

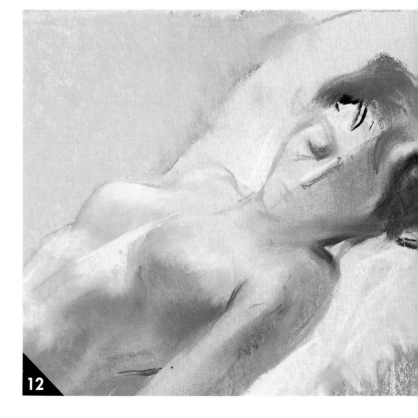

**9** These strokes of saturated carmine will become the darkest shadow of the figure. We apply them in zigzag fashion, so we will have a darker shade after blending than we would obtain with a single straight line.

**10** The carmine strokes are blended following the direction in which they were applied, thereby creating a sufficiently wide band of shadow.

### DIRECTION OF BLENDING AND STROKES

In general, we can blend in whatever direction we wish. Nonetheless, when we are modeling a figure or applying and blending colors along limbs, it is essential to blend in the same direction in which the original strokes were painted in order to obtain a uniform color, without smudges or breaks.

**11** We begin the work on the head by lightening it with white and pink, although only in the top part of the head, the area that is directly lit. The color of the rest of the head is a combination of carmine and the color of the paper itself.

**12** The head still requires work, but we can see how the shape of the hair is beginning to be developed with the application of burnt umber and blue, which make up the general color range we will be working with in this area.

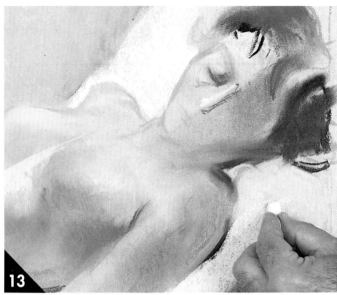

**13** With a stub of pastel, we energetically apply white on the pillow to make the figure stand out more sharply.

**14** We paint the leg the same way we do the rest of the figure: with long strokes of yellow and sienna, which are then blended, as well as some highlights of light pink where the thigh receives direct light.

**15** The leg is now blended to create a uniform tone.

**16** Here you can see the modeling of the entire figure, executed with large strokes, which give the figure's limbs a rounded or three-dimensional shape.

**17** Working on the figure as a whole, we develop the correct color harmony and feeling of volume.

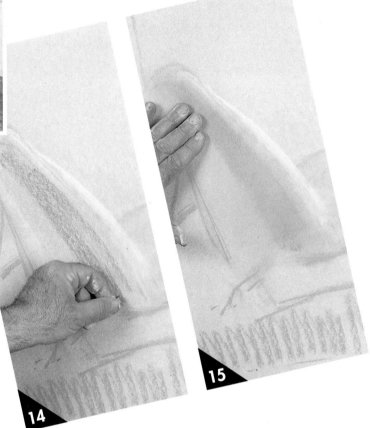

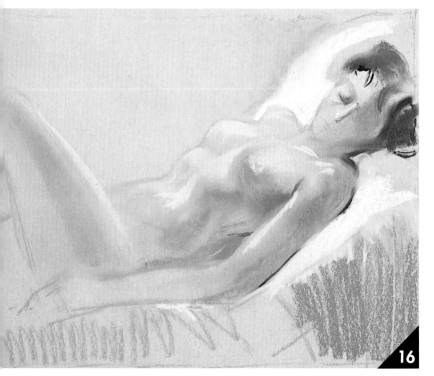

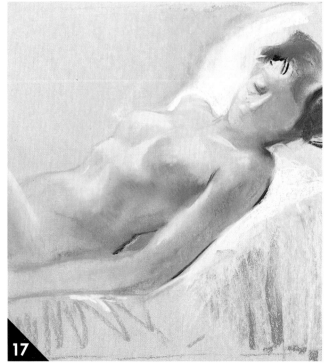

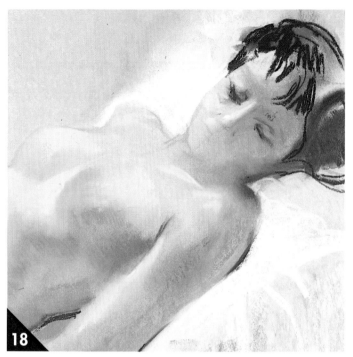

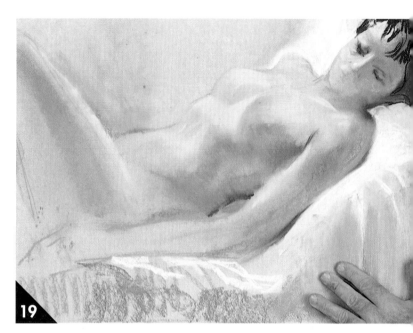

**18** Now we have added a number of details, such as the eyelashes, which both define the eyes and help to create the expression of the face, and the lines that represent the hair and create the correct contrast on the forehead.

**19** The lines that represent the creases of the drape are blended in accordance with the general treatment of the picture.

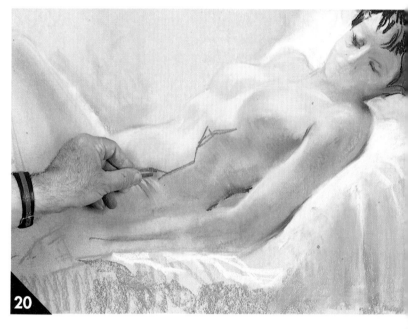

**20** Now we darken the shadow in the area of the ribs—that is, the shadow between the upper highlight and the reflection on the drape. To do this, we first draw a dark line around the edges of the area in shadow and then blend it.

### A NUDE IS NOT A PORTRAIT

When painting a nude, do not paint the face in detail. That should be reserved for portraits, where the expression is all important. The nude painting requires beauty of shape, not personality or psychology. Therefore, don't paint too many features in the face. Treat the face as just another shape.

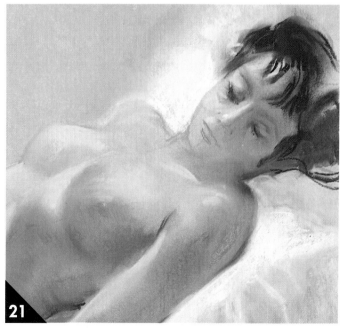

**21** Note how advanced the work on the head is now. In addition to the earlier work on the eyelashes and hair, we have added details to define the shape and volume of the nose and lips.

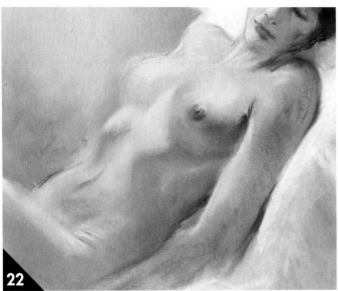

**22** Here we can see a slight darkening of the shadows as a result of the previously applied stroke. It is most evident in the area just below the breast, where the rib cage is prominent.

**23** There is little left to add. It is a good idea, however, to go over some of the contours, especially the ones that have become blurred due to successive blendings. The contour of the arm, for instance, has merged with that of the trunk; we redefine the shape by bringing it out with pink.

**24** One other final detail: reinforcing the high-lights on the thigh helps to give roundness to the form. We add a pink stroke, which harmonizes perfectly with the general color because it goes well with the blue of the background. The painting is finished.

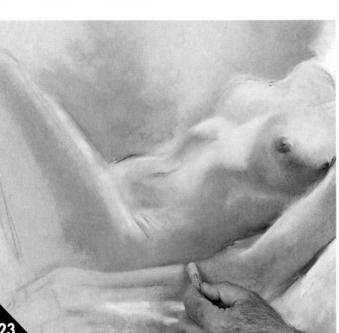

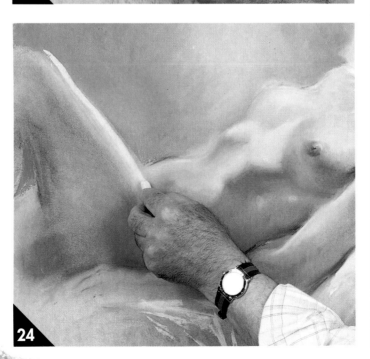

**25** We can see by the detail of the hand how it is necessary to make sure that each part of the body is "perfectly" finished. It is essential to know when to stop; any excess detail will overload the picture.

**26** This is the end result: a work of luminous tonality in which the vital transparent effect of a pastel painting has been correctly executed. The result of this picture sums up all the artistic possibilities of a pastel painting.

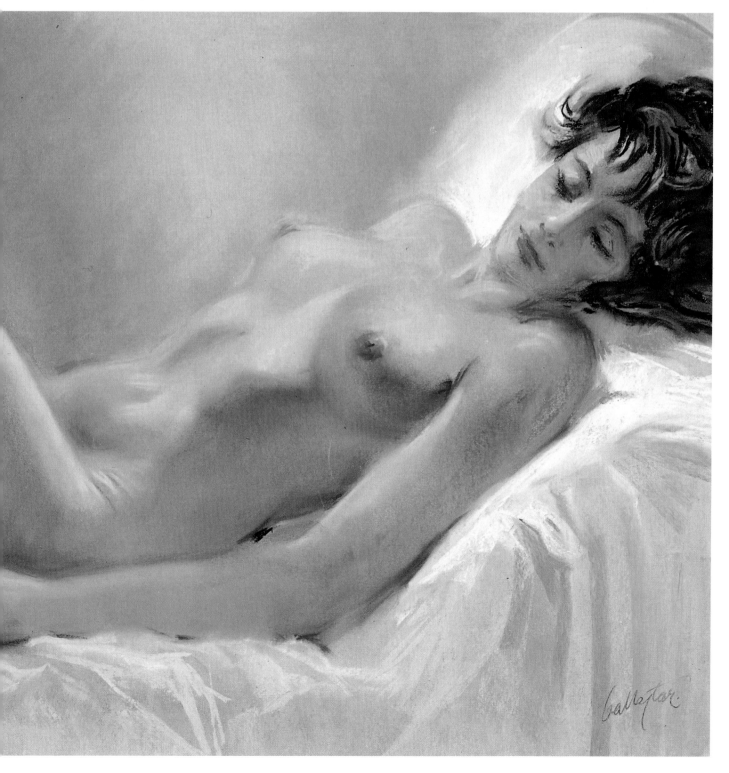

# A MALE NUDE IN CHIAROSCURO

W*e are going to tackle the problem of chiaroscuro, this time painting a male nude. For the first time in this book, we will use a dark colored paper, characteristic of the pastel medium. We have chosen a black paper, which is actually reddish brown. Don't worry—it is no more difficult to work on dark paper than it is on white. The only difference is that we start with the shadows and work toward the lights.*

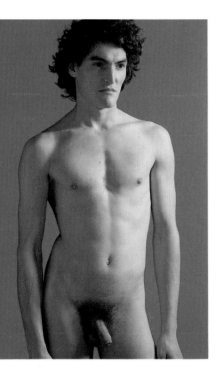

## MATERIALS

- Reddish brown Canson Mi-Teintes paper
- Complete range of pastels including greens, sienas, yellows, and cobalt blue
- Rubber eraser and kneaded eraser
- Clean rag
- Drawing board and pins

The background of the paper is filled in with cobalt blue, which creates an interesting contrast between the intense color and the dark shadows of the figure in chiaroscuro. In addition, the blue color highlights the flesh colors.

**1** The darkness of the paper compels us to sketch the figure in white pastel. We begin the sketch by marking out a vertical line, to divide the trunk into two, and two horizontal lines, to represent the shoulders and chest. These will serve as guidelines for constructing the rest of the body.

The darkest shadows contain green, violet, and burnt sienna, a dark combination that is effective in modeling the figure. The blending is complete, and lines are not visible.

**2** We add a few more details before applying the first color.

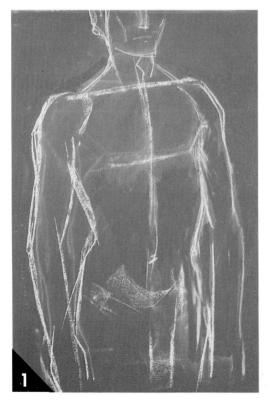

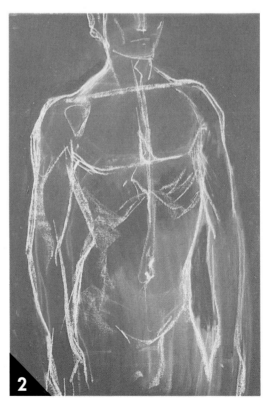

This part in half-light is dominated by green. As we mentioned earlier, light green is a useful color for developing the flesh tones.

The darkest shadow of this lower angle is reinforced with black, which is blended with the blue background. The hand is partly highlighted against the darkness and is softened by blending.

**3** The first strokes of color on the chest and arm are only approximate. We are assessing the general tone of the flesh colors. We apply the pastel stick horizontally over the paper, blending the color and mixing it with the next tone (at the moment, we are using pink and light green).

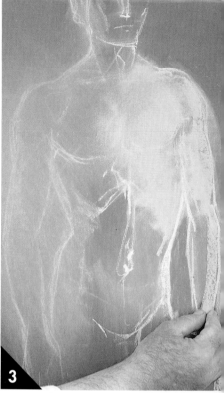

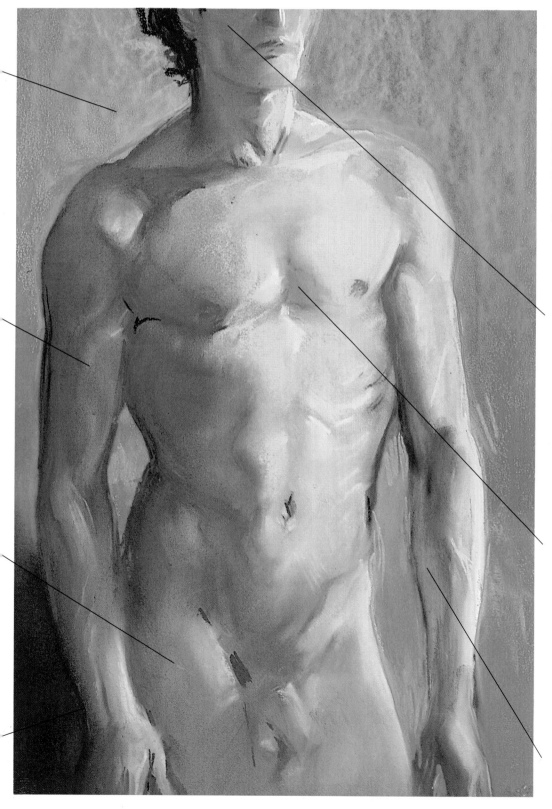

Only the general shape and volume as well as a few details of the head were defined; no attempt was made to bring out specific features or facial details.

Green plays an important role in this fragment. It was used as the base of the flesh colors and can be seen in other parts of the picture underneath the successive applications of warm and light colors.

The modeling of the arm shows strong contrasts of light and shadow, from the pink in the lightest parts to the sienna of the highlights to the green and umber in the central area.

**4** The color of the paper is used to represent the shadows cast on the figure. We merge the surrounding tones with the color of the paper by blending them at the points where the two converge.

**5** In order to obtain a good transition between the light and dark areas, we have applied some olive green to the shadows.

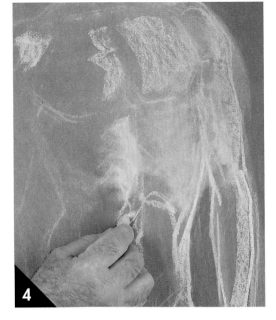

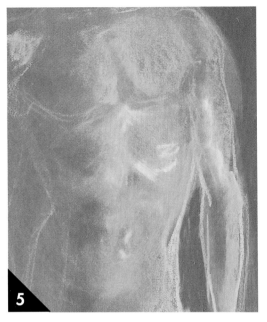

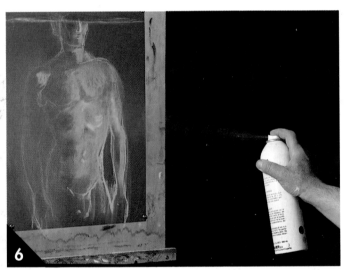

**6** We now spray fixative on the first color application. Fixative can be used in intermediate phases of work, but never at the end. Having fixed it, we now have a color base over which we can add more pastel color without having it mix with the previously applied color to become muddy.

**7** We are using a wide range of greens—from light yellow-green to olive green—colors that will subsequently be complemented with warm tones.

**8** This is the current state of the picture. Note the yellows we just applied over the greens, a perfect combination to represent the flesh colors.

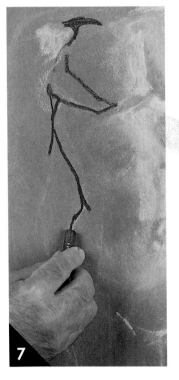

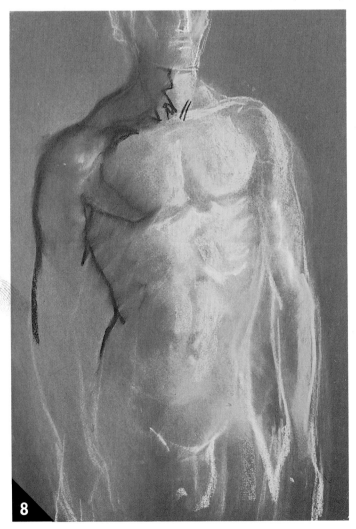

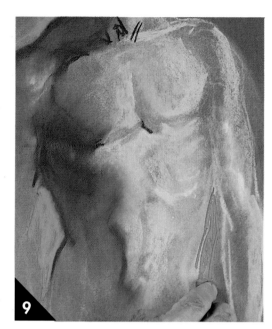

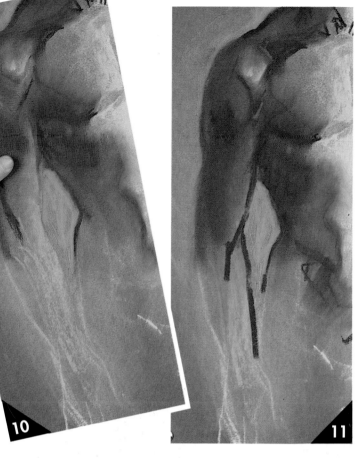

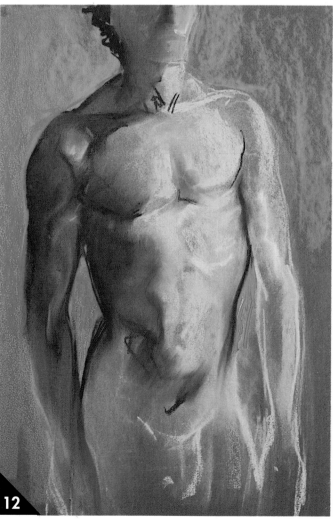

**9** The blue that can be seen behind the model is now painted over the dark paper. It is pure cobalt blue, without any other color added, and we apply it without blending so as not to lose the original intensity of the tone. The color covers the original color of the paper. Furthermore, the dark paper gives the blue an intensity and quality that could never be obtained on a light background.

**10** The problem of the arm immersed in shadows raises a question about the appropriate choice of color and value. Green and burnt umber best represent the darkness of the color of this part of the figure.

**11** We continue merging the shadowed parts with the background and highlighting the most illuminated parts.

**12** Here we can see how well the blue suits our needs. It reestablishes the contours of the darkest part of the arm without highlighting it too much. The combination of intense chiaroscuro and color is very attractive from an artistic point of view.

## FIXATIVE AND PASTEL

As we stated earlier, fixative should be sprayed on pastel paintings only during the intermediate stages. Furthermore, using fixative at this point is both advisable and desirable when working with successive layers of intense colors. The picture should be fixed before continuing the work in order to prevent the layers of pastel from mixing together and becoming muddy.

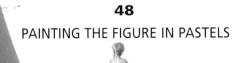

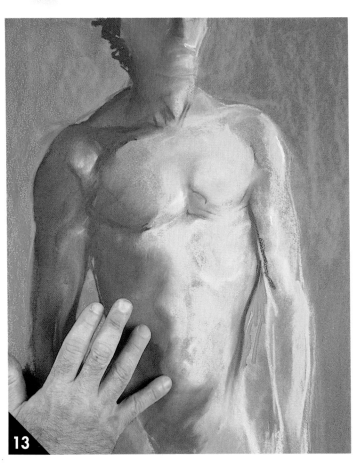

**13** Now we paint the shadows on the figure in dark umber, providing a tone more akin to the general warm tonality of the figure's flesh colors. Before blending, we should clean our fingers with the rag.

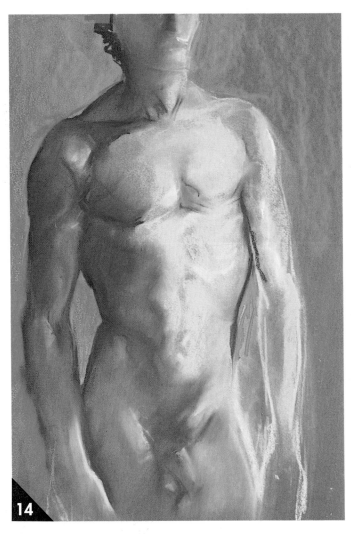

**14** All that is left now is to complete the highlighted arm and some details of the head. The rest of the body has been clearly modeled in the contrasting greens, yellows, and pinks that form the harmony of the flesh colors.

**15** The work on the highlighted arm is completed with pink lines and blending. The part receiving direct light is much lighter than the rest. Before blending this color, we clean our fingers. Mistakes and smudges are difficult to correct.

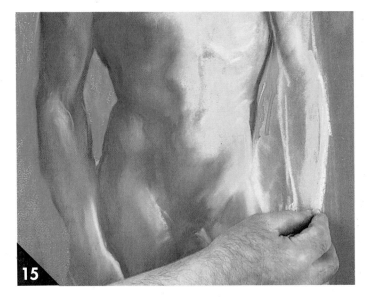

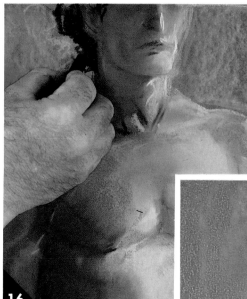

**16** We paint irregular strokes of cobalt blue in the background surrounding the head in such a way as to create the contours of the hair. Since the paper is dark, the paper itself becomes the color of the hair. The head does not need any more detail. If it were refined any more, it would contrast, rather than blend, with the rest of the body.

## COLOR AND CHIAROSCURO

Pastels allow us to achieve all kinds of possible effects of chiaroscuro, as well as to create intense color combinations. Blending makes it possible to combine both effects in one work: maximum chiaroscuro and maximum color strength. Harmonizing both factors depends entirely on the artist's powers of observation.

**17** The picture is finished. The strength of the chiaroscuro and color have enabled us to resolve a rather complex problem with simple techniques, in perfect accord with the nature and characteristics of pastel painting.

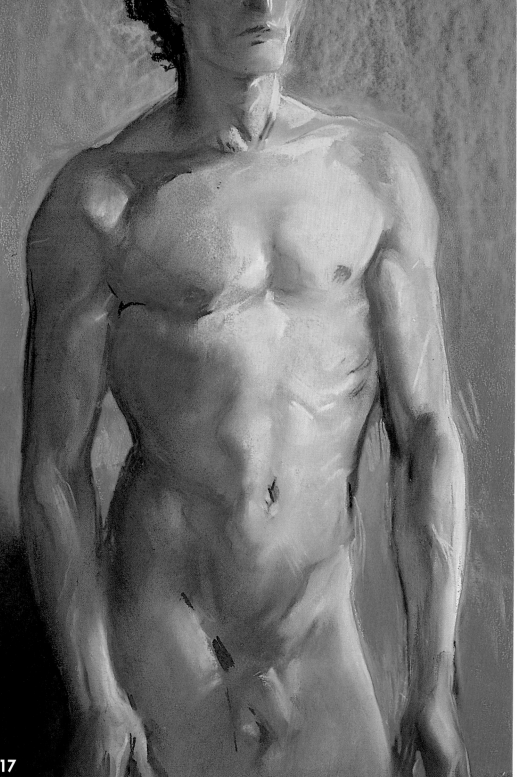

# A FEMALE NUDE IN AN INTERIOR

*T*he time has arrived to apply everything we have practiced up to this point. We are now going to work with color, modeling, and light and shade simultaneously and develop the painting to a more finished level than we have done in any of the previous exercises. The illumination is an attractive and interesting form of semiback-lighting, providing us with several possible ways to interpret this subject. In addition, the pose, the cushions, the rocking chair, and the setting lend the composition an intimate air that allows us to combine all techniques in one picture.

## MATERIALS

- Brown Canson Mi-Teintes paper
- Complete range of pastels
- Rubber eraser and kneaded eraser
- Clean rag
- Drawing board and pins

The blue of the drape is toned with different intensities of white, black, and blue. These tones were painted to emphasize the direction of the folds and the characteristic texture of the material.

The cushions are bright touches of color that present a focus of attention to balance the intense yellow in the background. Furthermore, these elements create an atmosphere of relaxation and tranquility.

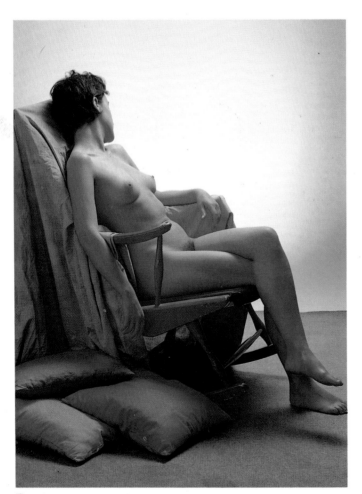

**1** In this exercise, we must take great care with both the drawing of the figure and the general composition of the work. The area and objects surrounding the figure need to be balanced in order to compose the picture as a whole. We begin by drawing the general forms of the composition with a piece of burnt sienna.

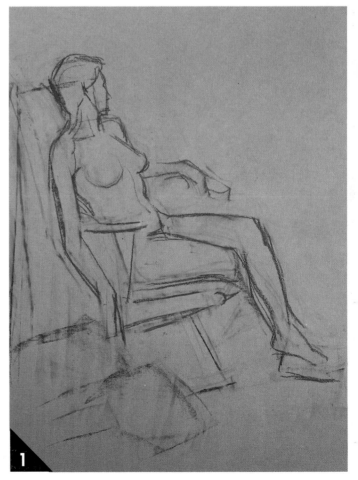

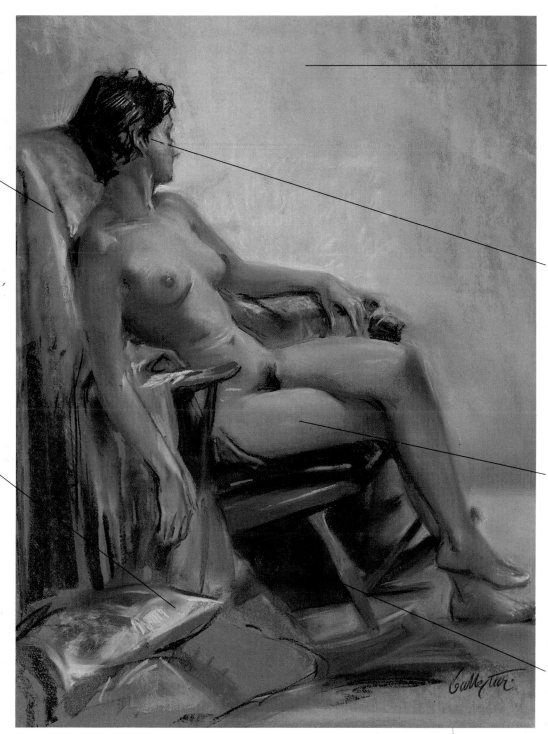

The yellow background adds luminosity to the work. The contrast between this light value and the soft tones of the figure is due to the semibacklighting that predominates in the scene.

This time, more detail than usual was added to the head—first, because a profile does not express the personality well, and second, because both the pose and the surroundings suggest a more personalized figure than on previous occasions.

Here we see how the form has a special velvety quality, due in part to the reflections of the blue drape that covers the rocking chair, but especially due to the softness of the lighting. In this area, the pastel strokes were blended very gently with a stomp.

This is the darkest area of the composition. The intensity of the black emphasizes the color and shape of the rocking chair, as well as the bright colors of the cushions.

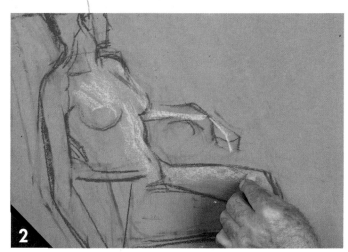

**2** The first strokes of pastel are applied very quickly. We are not concerned with filling in the entire figure. It is best just to apply a generous amount of color to the highlighted areas, in this case combining pink and cadmium yellow. As usual, we work with the flat side of the pastel stick.

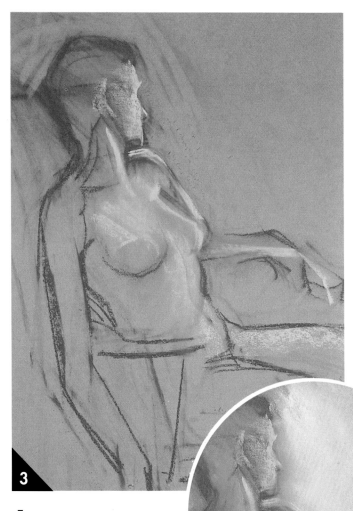

**3** With these first strokes of pastel, we are laying down color in the highlighted areas of the figure. For the moment, the color is left unblended, since we are concerned only with indicating the highlights. The detail of the face is interesting: one single flat stroke applied with the side of the pastel stick is enough to define the profile. This technique is characteristic of pastel painting.

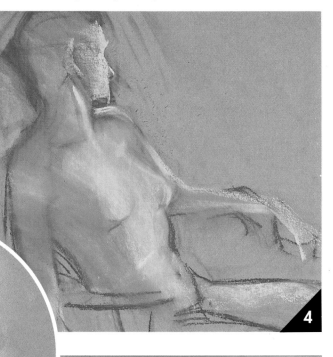

**4** Now we begin to blend the colors of the figure's body. Note how the harmony is based on light yellow, orange, and pink. By blending these three tones together, we succeed in suggesting the form of the trunk. We also start to paint the blue of the drape.

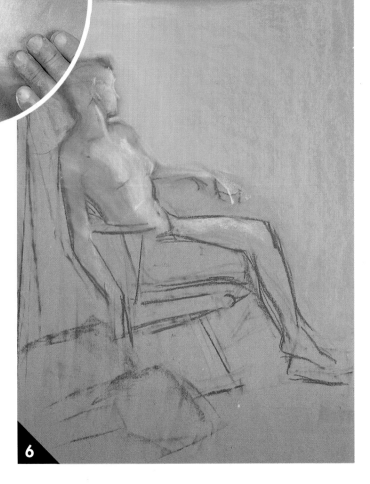

**5** Next we work on the background of the composition, blending the tone with our fingers. We begin working around the contours of the figure to define the contrast between the colors of the flesh and the color of the background.

**6** This is what the work looks like after filling in and blending the entire background. The background is obviously brighter than the figure; in fact, we are going to use a semibacklighting form of lighting, although without the extreme contrasts so characteristic of pure backlighting.

**7** Having applied the first layer of yellow over the background, we begin to superimpose a second one to saturate the tone and to increase its general luminosity. Here we can see how the contrast between the background and the figure appears to weaken the color of the latter, a problem we will immediately correct.

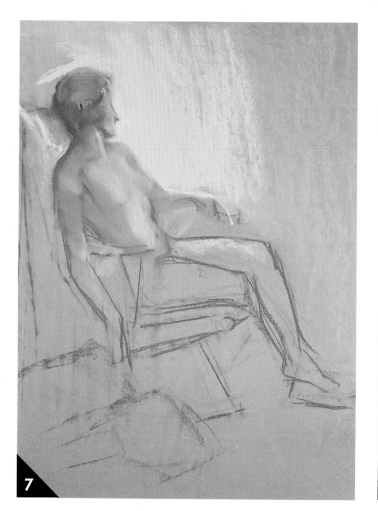

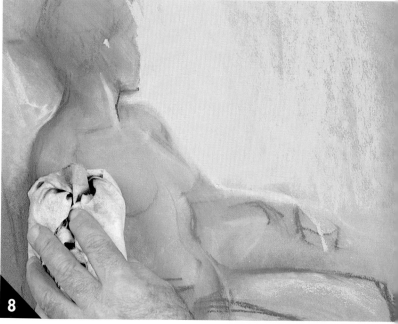

**8** We erase color with the rag. Fortunately, the layer of color is thin enough to enable us to clean the paper with ease. Since we checked the contrast with the background at the start, we can correct the work with relatively little difficulty.

## CORRECTIONS

When working with pastels, you should make all significant corrections during the first phases of the work. The rag is handy for cleaning color, but if you use it on a picture that is already at an advanced stage, you will muddy the color. Another solution is to fix the part you are going to correct and then paint over it.

**9** We substitute pink for the yellow in the body. Yellow in both the background and the figure would not be attractive. Now the contrast is much more effective and natural.

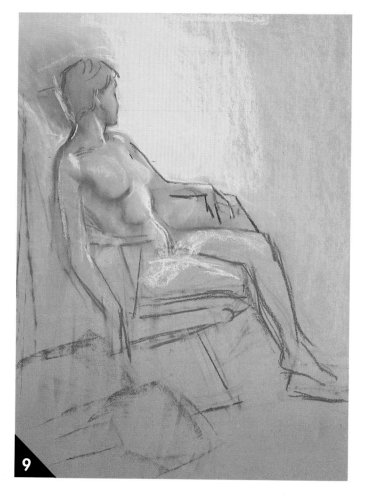

**10** To finish trying out the different effects produced by the surrounding colors on the figure, we have painted the blue of the drape, the result of which appears satisfactory. Also, we have painted the hair with sienna, black, and blue, thus creating a sense of the fullness of the hair as well as adding highlights.

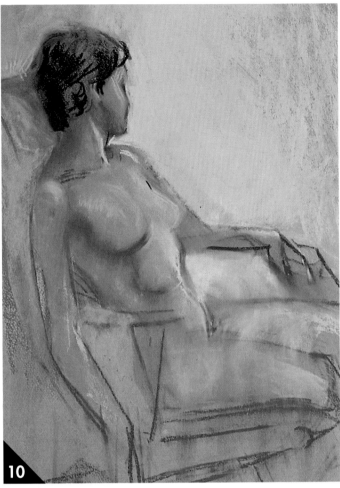

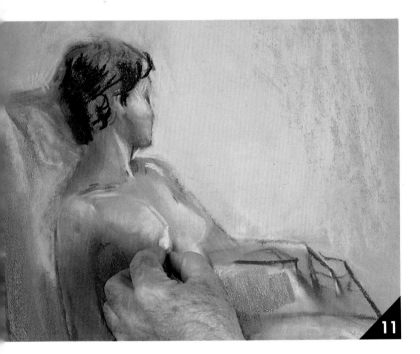

**11** We are now laying strokes of pink pastel on the breast, continuing to correct the color harmonization and reintroducing tones related to the contrasts established by the yellow background and blue drape.

**12** The work on the figure and its surroundings continues. The rocking chair and the drape are more clearly defined now; the modeling of the figure appears more natural and detailed than in the previous stages of the painting.

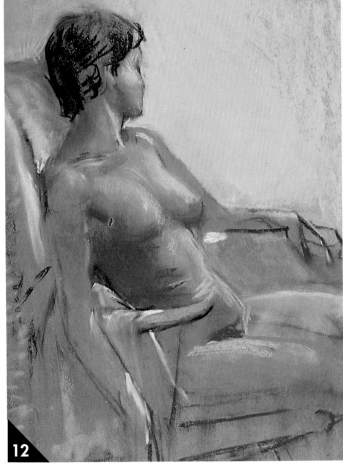

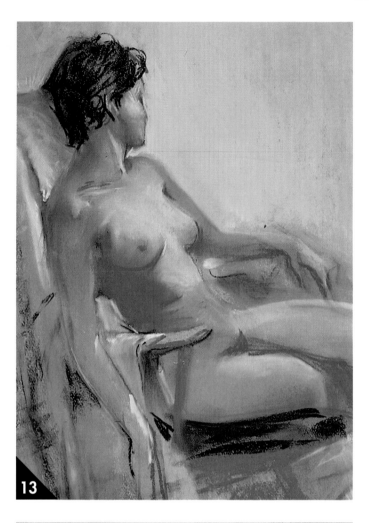

**13** Note how the shadow of the waist (on the inside) allows us to define the shape of the breast. We can also observe how the blue of the drape is enhanced by painting the different light and dark tones that create the effect of the folds of cloth.

### LINE AND BLENDING

A pastel painting in which all the colors are perfectly blended is a dull and monotonous work. Be careful when blending because too much softening will lessen the definition of the forms in the painting. You should combine blended areas with clear lines and unblended areas.

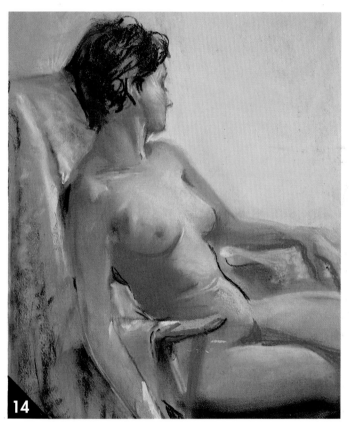

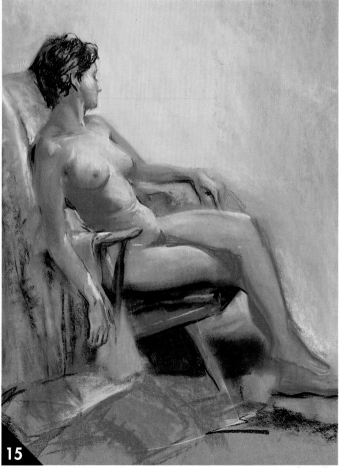

**14** The work on the hair is finished. The contrast between the intense yellow background and the tones of the body creates the pleasant and coherent effect that is needed in this type of composition.

**15** The cushions and the drape are an important visual focal point. Their lively colors lend a vibrant note to the general harmony and, furthermore, produce the effect of integrating the empty space of the foreground into the composition.

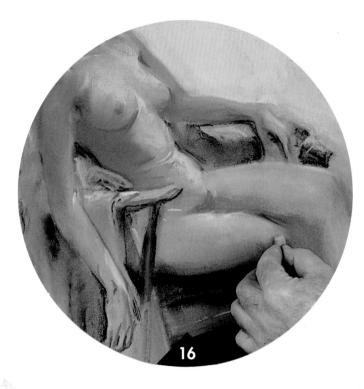

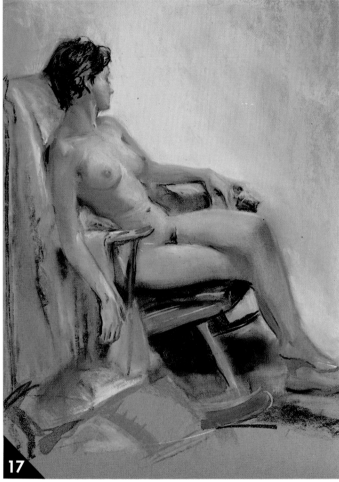

**16** We are now finishing the modeling of the leg by applying blue to the area in shadow, then softly blending it with the rest of the colors. This particular blue corresponds to the reflection of the drape and lends the flesh a velvety quality.

**17** The figure is finished. The only part remaining is the floor, which we paint in mauve, following the outlines of the cushions and the base of the rocking chair, defining the distances between them and unifying the elements into the composition as a whole.

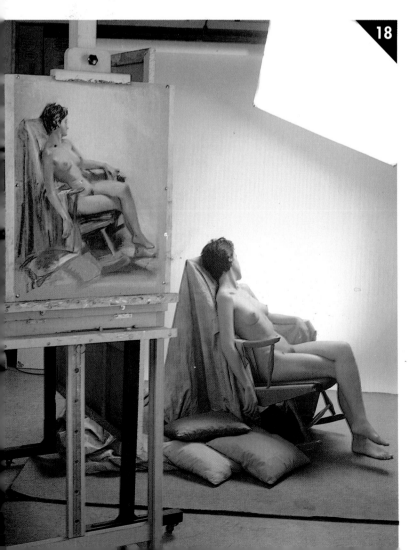

**18** This has been a long session and we deserve a rest. The model also needs to relax. Even though she has been seated throughout the session, she has had to keep totally still, which is always very tiring. Now is the moment to step back and examine the picture to see if any touching up is necessary. Everything seems to be in place—the colors are correctly harmonized and there is nothing more to add—so it is just a matter of signing the painting.

**19** We can feel proud of our painting, which is easily on a par with any oil painting—a perfectly painted picture, correctly composed, with a drawing and color that blend in perfect unity.

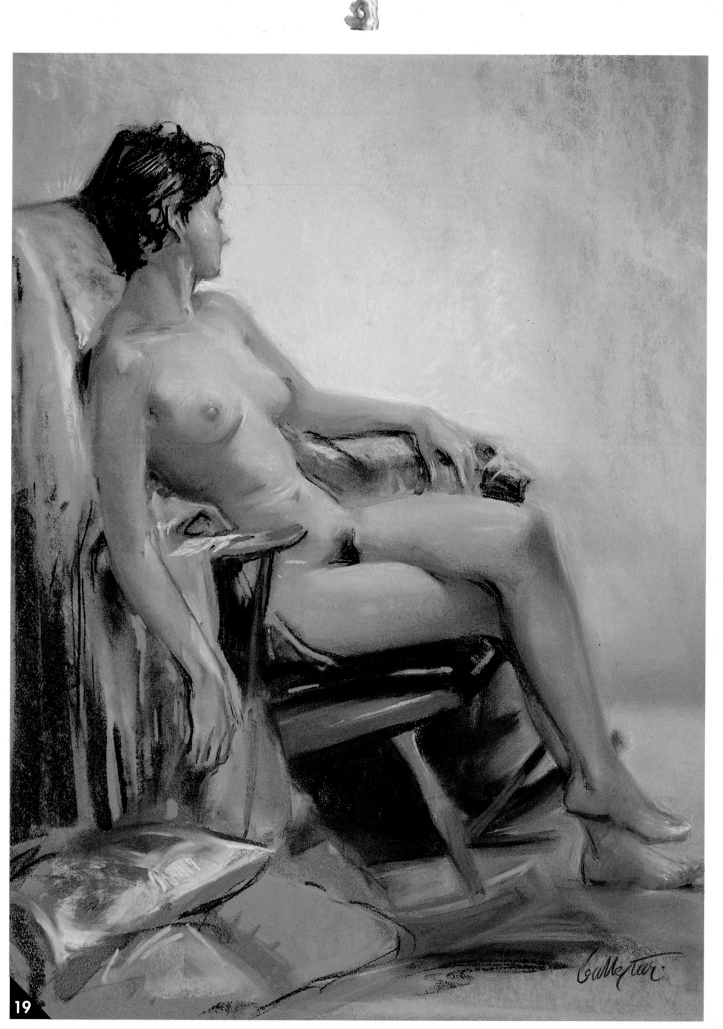

# A FORESHORTENED FEMALE NUDE

*T*he last exercise in this book is special because of the way in which the figure is situated within the spatial limitations of the paper. This type of drawing in perspective is called foreshortening. The main problem here is knowing how to draw the foreshortened limbs of the body correctly from an elevated point of view. Other than that, this is an easy exercise based on a reduced range of colors.

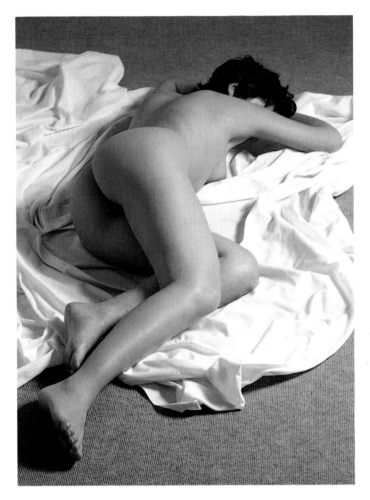

**1** First, a very quick sketch is drawn in which the foreshortened figure is indicated with several faint black lines. It is not necessary to draw basic geometric shapes as a guide. By careful observation of the model, we can simplify the figure, taking time to place it carefully within the format of the paper and to interpret the pose.

## MATERIALS

- Light gray Canson Mi-Teintes paper
- Range of pastels including ochre, light ochre, burnt umber, English red, white, and black
- Rubber eraser and kneaded eraser
- Clean rag
- Drawing board and pins

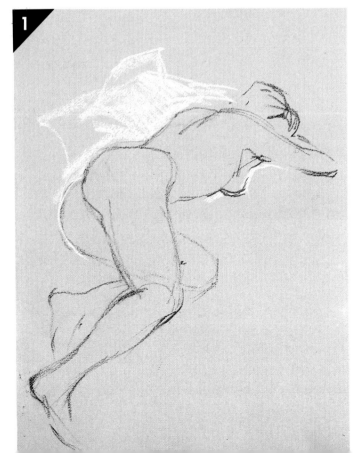

**2** To begin to suggest the rounded form of the legs, we blend several strokes. This also allows us to indicate the areas that will later need to be darkened, which we will do with color.

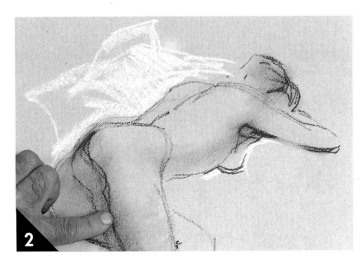

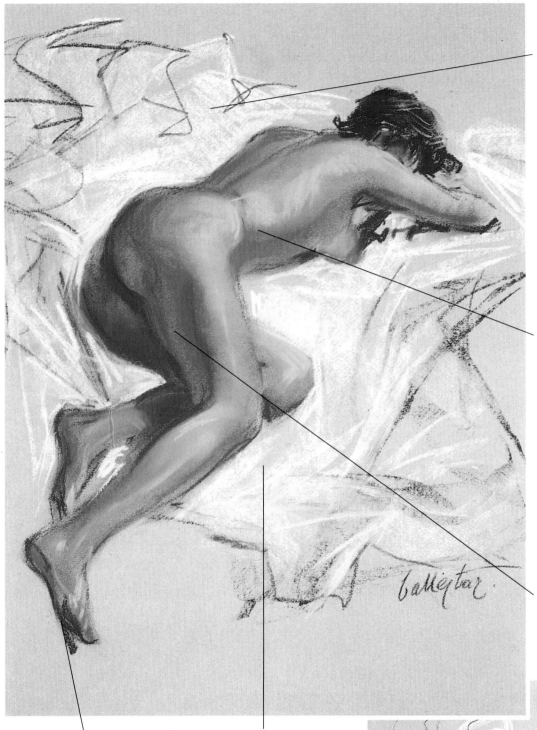

The foreshortened figure is portrayed from an elevated point of view, looking down on the nude model. The plane of the floor almost coincides with the plane of our paper. This is made evident by the position of the sheet, which defines the plane of the floor.

Here we can see how all the colors were used to model the figure: ochres, reds, and browns. This limited and subdued range of hues is enough to convey an impression of the rounded form of the model as well as of the shadows.

In addition to the pastel colors used, the gray color of the paper plays a role in the areas of darkest shadows. This is another example of the artistic possibilities of using colored paper for pastel painting.

The three-dimensional shape of the feet was emphasized by darkening the soles, thus creating a contrast to bring out their form. The feet play a major role in this picture because they are situated in the foreground.

The sheet was treated with fresh strokes of pastel, laid down rapidly without blending. Notice the way the color of the paper shows through the strokes of pastel, forming part of the completed painting of the sheet.

**3** We begin to fill in color, using first some English red along the contour of the calf. This is blended to provide a preliminary indication of the colors of the shadows.

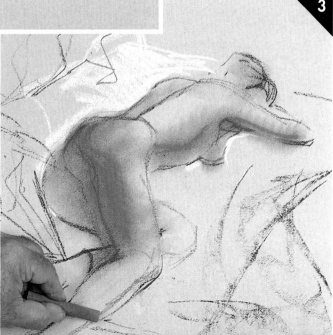

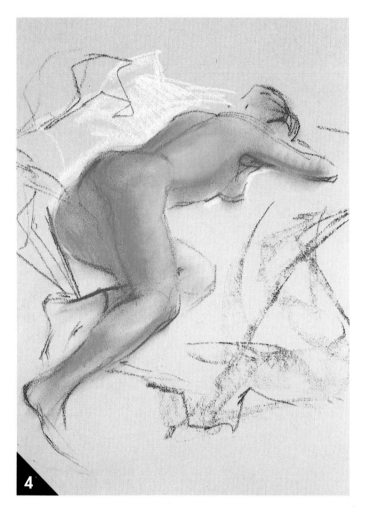

**4** Using only English red and ochre, we have established the most important values of the modeling of the figure. This work has been straightforward. The one thing we must remember is to blend pastels in the same direction as the stroke in order to obtain elongated shadows instead of shapeless ones.

**5** We now apply a lighter ochre over the original one to emphasize the highlights on the model's side.

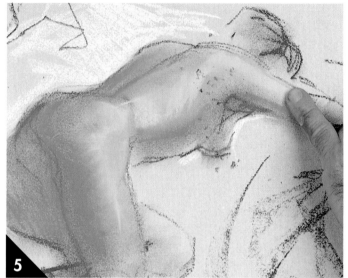

**6** The darkest areas are painted with burnt sienna. The technique used to paint the edges of the figure in shadow is the usual one: first draw the lines and then blend them with one finger until the color merges with the inner flesh tones.

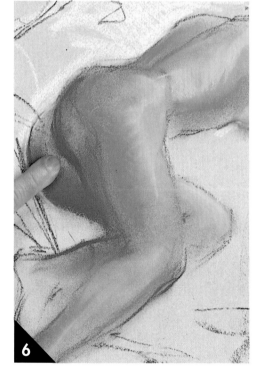

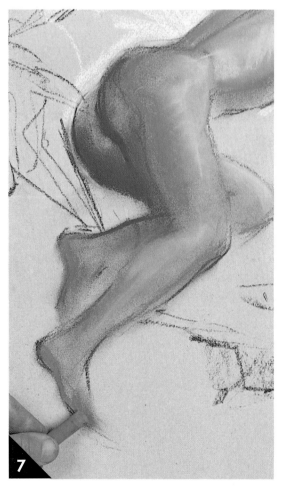

**7** We take up the English red again and paint the soles of the feet. They need this tone, slightly darker than the color of the legs, to show the effect of the lighting.

**8** We now concentrate on the sheet. The shape and creases were drawn beforehand with a series of loose strokes, without any attempt at precision. Now is the time to bring out the creases and folds in soft chiaroscuro.

**9** The original lines of the drawing are an enormous help for constructing the folds and creases, all carried out in white, by working with the flat side of the stick, without blending.

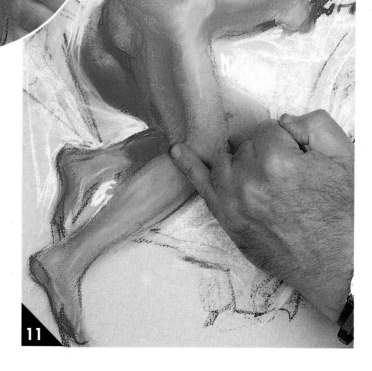

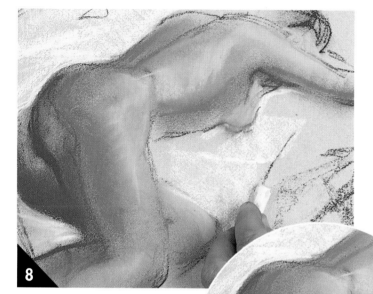

**10** We go over the shadows again to bring out the curves of the figure. Having reinforced the darkest shadows earlier, we now concentrate on the intermediate tones of the inner part of the body using the same technique: long strokes that are blended later.

### THE COLOR OF THE PAPER IS IMPORTANT

As we have demonstrated in many of these exercises, the choice of paper is very important in a pastel painting. The color of the paper is an invaluable aid for the artist because it contributes to the color harmony, for example by creating new tones or appearing as a transparent hue between colors. The correct paper will help you to paint better.

**11** We darken the shadow on the back of the thigh, blending this umber tone into the area shaded earlier in English red. This new, darker intensity heightens the three-dimensional aspect of the leg.

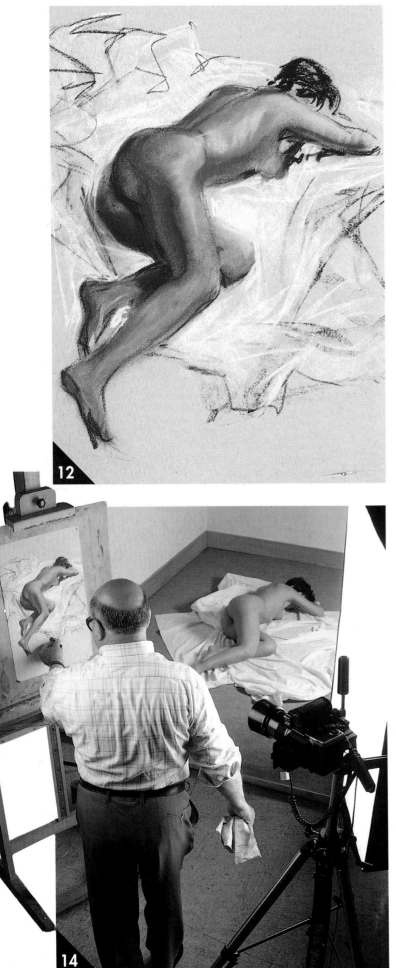

**12** There is little more to add now. The sheet seems to be complete and correct. The strokes of white on the gray background give the picture as a whole an appearance of freshness and lightness.

**13** The final touches to the calf are added. The flesh color is lightened at the edge of the shadow on the other leg to correctly define the shape.

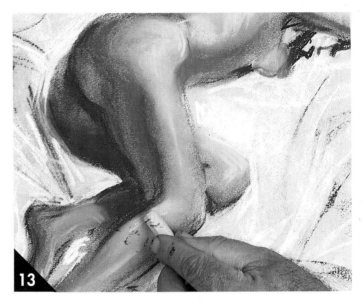

**14** Here you can see the distance between the artist and the model. This is an important factor, especially when dealing with foreshortening, in which everything depends on the point of view chosen, the distance from the subject, and the artist's eye level with respect to the composition.

**15** Mission accomplished: a pastel painting completed without many complications, in a simple and effective color range, and combining the meticulous work of modeling with the loose treatment of the sheet.

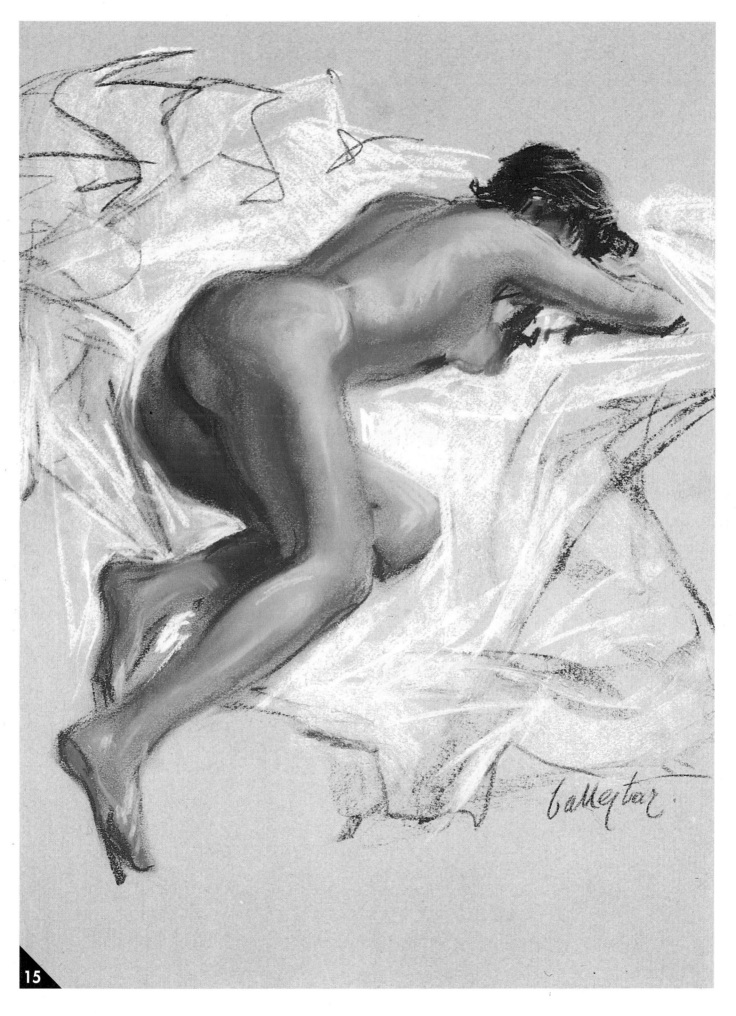

## Acknowledgments

I would like to express my sincere gratitude to Parramón Ediciones, S.A., especially to Jordi Vigué, series director, for allowing me to write this book and for providing me with all the necessary attention and help that contributed to the successful final product. Thanks go to Josep Guasch, for his extraordinary book design; to Jordi Martínez, for his collaboration and assistance at every step of the editing process; and to Joan, Jaume, and Toni, the photographers at Nos & Soto, for their splendid photography. I must not forget to thank the models, whose patience and understanding contributed to the excellent results obtained.

Finally, Parramón Ediciones and I together would like to extend our gratitude to the art supply store Vicenç Piera, in Barcelona, Spain, for supplying us with all the drawing and pastel materials.

Vicenç B. Ballestar

3606